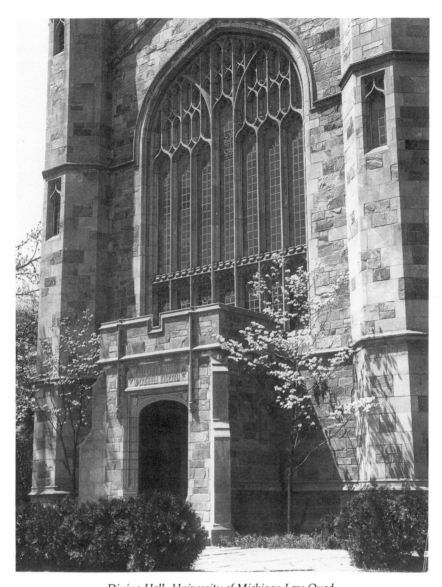

Dining Hall, University of Michigan Law Quad

The Uses of Art

Medieval Metaphor in the Michigan Law Quadrangle

Ilene H. Forsyth

Distinguished Senior Faculty Lecture Series
College of Literature, Science, and the Arts
The University of Michigan

Ann Arbor

THE UNIVERSITY OF MICHIGAN PRESS

Copyright © by Ilene H. Forsyth 1993
All rights reserved
Published in the United States of America by
The University of Michigan Press
Manufactured in the United States of America

1996 1995 1994 1993 4 3 2 1

A CIP catalogue record for this book is available from the British Library.

Library of Congress Cataloging-in-Publication Data

Forsyth, Ilene H.
 The uses of art : medieval metaphor in the Michigan Law Quadrangle
/ Ilene H. Forsyth.
 p. cm. — (Distinguished senior faculty lecture series)
 Includes bibliographical references and index.
 ISBN 0-472-09506-4
 1. University of Michigan Law School—Buildings. I. Title.
II. Series.
LD3285.L38F67 1993
378.774'35—dc20 93-5148
 CIP

In memory of George H. Forsyth, Jr.

Preface

When Dean Edie Goldenberg invited me to be the College's Distinguished Senior Lecturer for 1991, I was first warmed by the thought of the honor being accorded me and then chilled by my worry over how a university-wide audience might survive a series of lectures in my own esoteric specialty, Romanesque Art. I felt relieved as I learned that the lectureship is intended for senior faculty to reflect on their own growth and experience in scholarship and, by focusing discussion on ideas of basic importance to the liberal arts, to stimulate among the college and university community a sense of collegiality and common purpose. Thus was generated my plan to present some ideas I had about the influence of medieval cloisters and monastic metaphors of cloistrality on our academic environment, the presumption being that our own environment is surely a subject of interest to all. In addition, a study of medieval-modern correspondences might serve as a useful vehicle for exploring more deeply some of my most serious questions about the Middle Ages. Michigan's major example of a Collegiate Gothic ensemble, the Cook Law Quad, had long interested me, and I had already made some sustained researches regarding it. As I dealt with this modern quadrangle, I expected that some of my thinking about Romanesque cloisters would inevitably seep through and guide me in a search for its secrets, and I felt sure that as I prepared for my L S & A Lectureship, I would be able to delve much more deeply into the subject of cloistrality by exploring it on both medieval and modern fronts. The result was the lecture series entitled "The Ivory Tower: Monastic Metaphor at Michigan." The present volume represents the extended study that issued from this collegial experience.

I was aware from the beginning that when a medievalist takes up a modern topic, she is likely to require a great deal of help. Those who have assisted in myriad ways are surely beyond reckoning. Yet I would like for-

mally to acknowledge the particular aid of Dean Goldenberg and the members of the L S & A Executive Committee, who made the project, including its publication, possible, and to thank Patrick J. Young and Jeri Hollister, whose admirable skill with photography made it visually acute. Gerald Carr had earlier put his perceptive camera lens at my disposal and also has my sincere thanks. I am grateful as well for Thurnau research funds, which helped to underwrite the cost of the photography. With regard to my archival researches, Nancy Bartlett, with her broad knowledge and her enlightening counsel, was a friendly cicerone in my consultation of the Michigan Historical Collections at the Bentley Library. I am indebted as well to the aid and encouragement there of Director Francis X. Blouin, Jr., and numerous members of his staff. At the university's Engineering Services, Pamela Hamblin and Jack Janveja were most helpful. I owe gratitude also to Janet Parks, who presides over the Archives and Drawings Department at the Avery Architectural Library, for her gifts of time and guidance, and to the staff of the New York Historical Society for their assistance. In Hillsdale, Pamela Trowbridge and Dr. Jerome A. Fallon were helpful, and Charlotte Benge, of the Hillsdale County Historical Society, generously and knowledgeably assisted my researches in the Historical Room at the Mitchell Public Library. In Ann Arbor, Dr. Alice Sunderland Wethey and Dr. Elizabeth Sunderland provided valuable assistance, as did Margaret and Nicholas Steneck, who have followed the history of the university with great learning and insight. The informative Steneck lectures are a sine qua non for all friends of Michigan and a model for medievalists who wish to explore the question of the survival of *mediaevalia* in our own time.

My thanks are extended also to a distinguished and wise alumna of the university who is a descendant of William Wilson Cook himself, his grandniece, Ann Bradford Cook, who graciously spent many hours with me discussing the Cook family and its history. As to the perspective of the Law Quad from the Martha Cook Building, the major earlier benefaction of William Wilson Cook in Ann Arbor, I benefited from discussion with Nancy Sudia and with Rosalie Moore.

At the Law School, Dean Lee Bollinger encouraged my efforts, and I was especially aided by Margaret Leary, Beverly Pooley, Elizabeth Gaspar Brown, Henrietta Slote, Lillian Fritzler, Diane Nefranowitz, Anne Knott, Marie Deveney, Bruce Frier, John Reed, Eric Stein, Peter Steiner, and Joseph Vining. Other colleagues who contributed to my thinking about the Law Quad include John Cameron, John Cross, Joel Isaacson, Diane Kirkpatrick, John Knott, Linda Neagley, Graham Smith, and Nathan Whitman. Elizabeth

Thoburn cordially put her work on art in public places at my disposal. My own graduate students were often a source of stimulation to my thinking about the quadrangle, and to those who aided me as research assistants, Linda Bangert, Lisa Bessette, Mariana Giovino, Melanie Holcomb, and Rebecca Price-Wilkin (whose drafting skill was a critical aid), I am especially grateful. To those at the University of Michigan Press who have helped my ideas about the Cook Law Quad reach a wide audience I also owe my thanks. Friends and family were not spared the task of helping, and they include Hope Forsyth Platt, John Harold Worth, and Mary Blaikie Forsyth Worth.

Although I wish to express my gratitude to all of these people, I do not wish to implicate them in any of my shortcomings. Responsibility for the work that follows, including any flaws it contains, is fully my own. I hope that in addition to whatever intrinsic interest it may have for readers, it will also serve as a token of my appreciation to the university. When, as an adolescent, I first sat on the cool stone bench in the Law Quad and decided that Michigan was the university for me, and when I later lived under the vaults at Martha Cook, I did not suspect that I would one day be a medievalist, that I would come back to Michigan later in my career, and that there would come an opportunity to speak to some of the insights engendered by these early experiences at Michigan. This is the day to express my warm thanks for these years.

This small book is dedicated to the memory of my late husband, George, who heard much more about the brilliant and generous curmudgeon Cook than he needed to know and who did not, alas, live to learn how it all turned out. In George the ideals represented by the best of Cook were also strong.

Grateful acknowledgement is made to the Michigan Historical Collections, the Michigan Law School, Michigan Engineering Services, Michigan Information Services, and the Avery Architectural Library for permission to quote from documents in their collections.

Ann Arbor, October 2, 1992

Contents

Abbreviations

AA Avery Architectural and Fine Arts Library, Columbia University, Drawings and Archives

MHC Michigan Historical Collections, Bentley Historical Library, University of Michigan, "The Law School"

UMESA University of Michigan Engineering Services Archives

UMIS University of Michigan Information Services

UMLSA University of Michigan Law School Archives

UMPS University of Michigan Photographic Services

Introduction: The Character of the Cook Law Quadrangle—A Place Apart

Within the architectural diversity of Michigan's Ann Arbor campus, a campus with a spread and a variety as extended as that of the university community itself, there is a place apart: the Cook Law Quad (figs. 1–3).[1] The distinct ambiance created by the quad's buildings seems at variance with the mélange that marks the rest of the campus where the free growth of the university over a long period of time has resulted in structures of various styles and uneven levels of distinction. Yet the quad's special character is not simply a matter of its architectural unity, as is often claimed. There are a number of other quadrangles on the Ann Arbor campus that have single styles but lack its expressive force. The Law Quad's special capacity to function well and delight the eye while also expressing the ideals it is meant to embody is rare. Its ability to evoke a sense of place imbued with the spirit of collegiality while also suggesting a place where the intellect might be harbored, nurtured, and even elevated is striking. As they function, the buildings form a coherent and complete ensemble, allowing the manifold activities of a large law school to operate in a single center where students, faculty, and distinguished visitors of the legal profession can reside, dine, study, develop professional competence, and carry out broad-ranging research in an academic environment very like an academy or in the manner of the old English Inns of Court. The single architectural mode of the Cook Law Quad certainly enhances the cohesiveness of such academic goals, but there are also other, more intangible factors that affect its expression of ideals, such as the scale, disposition, and design of its structures; the articulation of these with color, texture, and decorative amenities such as ornamentation and inscriptions; and, finally, the massing of the forms, their impact on the spaces about them, and the associations

conjured up by them. All of these contribute to the quad's art and to its ultimate effect. It is an effect that inspires. It has been a sufficiently powerful effect that preservation of it has been called for by alumni and faculty of the school and it has been acknowledged as the primary reason that the brilliant addition to the library, entrusted to Gunnar Birkerts during the late 1970s and early 1980s, was carried out underground (fig. 4).[2] The architecture of the Cook Law Quad may thus be considered felicitous in accomplishing the high aims of architecture as one of the great arts.

The purpose of this book is to explain how this success was achieved. That it was achieved is remarkable. An enterprise of such huge extent, involving at least fourteen architects and architectural draftsmen, dozens of tradesmen, hundreds of laborers, and occupying more than a decade (ca. 1919–33) during the tenure of four Michigan presidents, numerous regents, and countless faculty committees—all subject to the multiple voices often resonant in democratic discussions of large, state university projects—would not seem to have acceded readily to architectural harmony. Moreover, Michigan lacked a distinctive architectural tradition that might have propelled such a project along a uniform course, as at some of the ivy league institutions. Indeed the contrary, heartland tradition of resistance to architectural lavishness and display, which had brought down earlier proposals for Ann Arbor such as Alexander Jackson Davis's distinguished plans in 1838, had to be surmounted.[3] Chance also played a sometimes capricious role. Yet from such a seemingly intractable situation, multifarious forces were welded together, and the work surged forward to a unified result, culminating in the Dedication Exercises of 1925, for the first phase of the project (the Lawyers Club residences along South University Avenue and the Dining Hall on State Street), and those of 1934, for the completion of the second phase (the John P. Cook residence, the law library known as the Legal Research Building, and the law school administration and classroom building known as Hutchins Hall).[4]

Although complex, the creative process that brought these buildings into being might be of only local interest were it not for the fact that the particular forces and circumstances in this case can be charted. That is rare. It would be impossible for a distant era such as the Middle Ages, where documentation is fragmentary. It would also be less feasible for architectural projects larger in scope, with more diverse objectives, with various funding sources, and with mutiple patrons requiring the satisfaction of memorial interests with varying visions. In our case there was a single patron, William Wilson Cook. He was also single-minded in his purpose and in his determination to steer

the project unswervingly toward his clear goal. His ample wealth simplified the funding process and allowed an almost unbroken series of campaigns as he pushed on to his objectives. They were given edge as the specter of ill health hovered over him during the decade. Fortuitous circumstances provided the conducive social environment of the "roaring twenties," a period of exceptional growth, prosperity, and buoyant spirits between the First World War and the precipitate decline of the crash of 1929. Before the collapse of Wall Street brought long years of depression, the university participated in the expansionist fervor of the 1920s with its "Burton building boom." Even so, had it not been for a happy confluence of gifted and strong personalities, the law school project might have been aborted. While the passionate, tyrannical, albeit admirable "curmudgeon" Cook, who considered himself captain of the enterprise, was assuredly the nexus of it all, a number of people who interacted with him, including the dean of the Law School, Henry Moore Bates, the librarian, Hobart Coffey, and the secretary of the university, Shirley Smith, were critical to the success of its outcome. The major figures in addition to Cook were President Harry Burns Hutchins and architect Edward Palmer York.[5] The momentum generated by the tensions of their intense exchanges for more than a decade carried the work through to completion even though by June, 1930, York, Hutchins, and Cook were all dead.[6]

Thus, the product created by this process shows itself here not to have been the brainchild of one man with a mission or one inspired artist with an appropriate masterwork as his mental image, or even to have been the issue of a simple artist-patron relationship, the patron making requests that were then brilliantly executed by the artist, but the result of a dialectic at once more dynamic and more complex. Decisions continually depended on the markedly *interactive* character of the process, and sometimes they were the consequence of accident. As art historians today are eager to understand art in its social context, the discoveries that emerge from research on the Cook Law Quad may be helpful. Similar creative processes seem to me characteristic of numerous successful artistic commissions, including some of the greatest in history. Architectural enterprises are usually corporate enterprises, and they require delicate coordination of the arts. Such coordination might thrive on the synergistic chemistries of comparable interactive dynamics. With the expectation that charting the Michigan enterprise might throw some light on others that can be only dimly traced, I have pursued research on the Michigan Law Quad more vigorously than it might otherwise seem to have merited. My hope is that my findings may illumine the general subject of patronage in art as I present this case history.

NOTES

1. Robert A. M. Stern, *Pride of Place: Building the American Dream* (Boston, New York, 1986), pp. 41–83, discusses related campuses. See also Charles Z. Klauder and Herbert C. Wise, *College Architecture in America and its Part in the Development of the Campus* (New York, 1929), p. 33.

2. For an introduction to Birkerts's work on the law library addition, see "Beneath the Surface," *Architectural Record*, March, 1982; Noreen Wolcott, "A Proud Tradition, A Timeless Profession," *Michigan Alumnus* 90 (February, 1984): 14–26. For the addition to the library stacks in the aluminum style of the 1950s, see John Fallon, "Extensive Addition to Library Planned," *Res Gestae* 4 (1953): 3. Only the buildings of the Cook commission are dealt with in the present study.

3. Paul V. Turner, *Campus, An American Planning Tradition* (Cambridge, Mass., 1984), p. 124 n.69; Richard P. Dober, *Campus Planning* (New York, 1964), p. 30; Jane B. Davies, Francis R. Kowsky, Amelia Peck, et al., *Alexander Jackson Davis, American Architect 1803–1892* (Metropolitan Museum of Art, New York, 1992), pp. 50–51, fig. 2.14, pl. 28.

4. *Addresses Delivered at the Dedication of the Lawyers Club of the University of Michigan, June 13, 1925* (Ann Arbor, 1926); *Dedicatory Exercises of the Law Quadrangle, University of Michigan, June 15, 1934* (Ann Arbor, 1935).

5. Hutchins was dean of the Law School, 1895–1910, then president of the university, 1910–20; he continued to be actively engaged with the project until his death in 1930. York, both pragmatist and visionary, was the chief architect in charge of the project. He was senior partner along with Philip Sawyer in the firm of York and Sawyer, which the two men founded in 1898. Sawyer was also central to the Ann Arbor project and took over its direction from the time of York's death until the completion of the work in 1933.

6. York died December 30, 1928; Hutchins died January 25, 1930; Cook died June 4, 1930.

Cook: The Patron as a Mythical Figure

William Wilson Cook made a stunning impact on the history of the university with his gift of the Law Quad, and yet he seems an almost mythical figure. We have only vague knowledge of his persona, as no photograph of him exists. An engraving (fig. 5) appeared at the time of his student years at Michigan, but he shunned efforts to secure photographs or portraits of him that would represent him in his maturity. As the first phase of his Law School benefactions was nearing its conclusion in 1924 and the handsome buildings along State Street and South University had become a reality, Dean Bates made repeated requests for a photograph, all of which were declined. A portrait was especially sought when a commemorative publication was being planned in conjunction with the dedication ceremonies of the Lawyers Club in 1925. This request took on urgency when it was discovered that Cook himself would not attend. Instead of a photograph, Cook sent a letter in which he set out his ideals and aspirations for the Law Club and for the legal profession at large. Cook made himself present through the force of his words.

A detailed description of these ceremonies survives in a letter by I. Elbert Scrantom, whose firm had provided the interior furnishings for the buildings. For Scrantom the dedication was a "wonderful event." He was profoundly impressed by the entire matter as he enthused over Cook's aims and ideals, as set forth in his "excellent letter," and the greatness of his gift. Yet there is one thing, he wrote, "that stands out foremost, however, and that is that you appear as a mythical character." All want to know "what . . . you look like."[1]

In the same letter Scrantom refers to the numerous discussions he had already had with Cook urging that he have his portrait painted. Posterity ought to have some likeness of him passed down. Scrantom took up the matter with the man Cook sent to represent him at the dedication exercises,

John Creighton, hoping that Creighton might succeed in persuading Cook to allow a picture. Creighton reopened the question of an oil portrait when the publication of the dedication addresses was imminent. He was again turned down.[2] To the present day, we have only the above mentioned engraving and a bronze death mask, commissioned by the university and made by Georg J. Lober following Cook's death in 1930 (fig. 6).[3]

Although averse to pictorial images of himself, Cook was not the least reluctant to express himself in words. His professional writings occupy much shelvage and include eight hefty editions of his classic work on corporations (*Cook on Corporations*); his *Power and Responsibility of the American Bar*, 1922; his compendium, *Principles of Corporation Law*, 1924; and many other legal publications. There are also a number of writings that embody his thinking about society in more general terms, such as *American Institutions*, 1927.[4] Of greater relevance to his benefactions is his preserved correspondence, which is voluminous. Thousands of letters survive. In these Cook explained himself with exceptional brilliance and lucidity. Although his stiletto wit often seems outrageous, it usually hit its mark precisely. The vigorous surprises that leaven this writing and the forceful, driving nature of the writer, which propelled the project forward without caesura to the very end, are impressive. In his preliminary statement at the dedication, John Creighton characterized Cook's work on the Law Quad project as an analogue to his book on corporations, both being the result of the most painstaking effort. Cook's genius expressed itself in the capacity for "taking infinite pains, daily care and thought," working in the most thorough manner, and giving the task the best that was in him: "Cook's predominant characteristics are an irresistible concentration of mind, linked with force of accomplishment."[5]

During his concentration on the project, Cook seems never to have left the bridge as he conned his ship through the tempestuous waters roiled up by his enterprise. Others might go off to Bermuda (York) or England (Sawyer) or northern Michigan (Bates) for brief respites at vacation time, but during the work Cook seems never to have been away from his desk. He dictated and Emma Laubenheimer typed a torrent of letters dealing with the project.[6] He followed its progress avidly, tenaciously involving himself with the slightest detail. His attention was intense, expanding with discussion of broad matters of planning and yet also focusing with precision on minor matters such as fittings and decoration and, of course, cost. He pored over the plans, continually revised budgets, and studied with an eagle's eye the photographs sent to him on a regular schedule, boldly querying matters that ranged from window curtains, typewriters, clocks, and boiserie to relative roof lines, lime-

stone, and gutters (for example, early in the first construction phase, he complained of signs littering the site; at its end he asked for better photos that could be taken from the more effective vantage point of the roof of the Michigan Union). His unflagging engagement with the work was perhaps not always appreciated, viz., the remark of Dean Bates (that Cook involved himself tirelessly with Michigan affairs) and a comment by chief architect York ("rare that a client gives an architect the opportunity to do things right and requires such a complete result"), both reflecting slight traces of irony.[7]

Cook's consuming interest poured out in words, chiefly in his private and public letters. As Cook was aware of the magnitude of the events his actions would entail, his public letters about them were carefully composed. He expected the letters to pass under the eyes of numerous university officials. He expected them to endure as documents of history and also as contracts he was in effect making with the university. He must have hoped that they would also inspire the future, and indeed a portion of his final letter of gift ("Believing as I do . . . "), incorporated in his will, is cast in bronze and immured at the entry to Hutchins Hall. In these letter-statements, he clarioned his motives, to the regents ("I will erect . . . ," April 25, 1922; "I will erect . . . ," January 11 and April 26, 1929) and to members of the Law Club ("I believe . . . ").[8] His public statements in stone trumpet his intentions even more sharply, as they are monumentalized in the large inscriptions carved over five of the quadrangle's gateways (Appendix A). These were meant to grace the buildings and to inform them with meaning. They were composed by Cook and put through numerous redactions as Cook sought the exactly correct wording for them. They made Cook's goals and ideals, his deepest and most heartfelt beliefs, legible and accessible to all.

From these many manifestations of Cook's verbal self-expression a portrait of a sort emerges. It can be refined with the slight information we have about his family background and his life beyond the Law Quad. He was born in Hillsdale, Michigan, April 16, 1858. He was the fourth son of the nine children born to John Potter Cook and Martha H. Wolford. Cook had Henry Caro-Delvaille paint portraits of both parents in 1916–17, based on daguerreotypes, and these hang in the buildings named respectively for them.[9] Martha is memorialized, of course, in the women's dormitory, the Martha Cook Building of 1915. She was born near Auburn, New York, September 7, 1828, of prosperous family. She married John Potter Cook in 1852 and came west to Michigan with him.[10] Although not highly educated, she is said to have kept a journal for two years following the death of her husband, and

she is known to have been warm, generous, highly virtuous, and very influential in William Cook's early life. Over the hearth in the grand dining room of the building named for her, Cook's first major benefaction to the university, is the carved stone inscription, also determined by Cook: HOME, THE NATION'S SAFETY.

The biography of Cook's father, John Potter Cook, is fuller and has already been sketched a number of times. He was born in Cato, New York, January 27, 1812. He claimed ancestors distinguished in American history, Governor William Bradford of Plymouth among them. He moved to Detroit in 1832 and then to Hillsdale in 1836, where he was an important founding father. His successes in many spheres of activity are recorded: he built a flour mill, a saw mill, a foundry, and a bank, and he had mercantile, fruit, oil, and lumber interests, some of these in partnership with Chauncey Ferris, another town father. He was influential in the locating of railroad lines through Hillsdale, and he also served the town as its postmaster, a member of the board of education, and a trustee of Hillsdale College. In addition to being county treasurer, his statesmanship was attested by his offices in the state legislature (1845) and the senate (1846) and by his service as a delegate to the Michigan Constitutional Convention in 1850.[11] In the 1850s, he installed his family in a newly built mansion, at 139 Hillsdale Street, where there were ample grounds and attractive gardens with specimen plantings, the whole surrounded by low, stone walls of granite (fig. 7).[12] This is where young Will was reared.

On April 16, 1875, John Potter Cook wrote a birthday letter to his son Will: "My boy, William, seventeen years old. In ten years' time your course of life will undoubtedly be settled upon. These two years of your life to come will probably control your whole future. May you pass through them observing the same temperate habits you have maintained thus far, and always in the future observe the recognized rules of success—morality, virtue, industry, and economy. With my prayers for your future success and greatness. Your father, John P. Cook." This letter must have been important to William. He preserved it and had it displayed with the portrait of his father in the John P. Cook Memorial Room of the building likewise named for him. Through the father's words, we catch another glimpse of Cook, the son.

At the time of his father's letter, Cook must have just completed his studies in the local Hillsdale schools. He then attended Hillsdale College for a short time, leaving there for the University of Michigan, where he received his A.B. degree in 1880. In 1882 he completed his law degree, then called an L.L.B., and entered the legal profession.[13] After a short stay in Toledo, at the

firm of Scribner, Hurd and Scribner, he went on to New York, where he was admitted to the New York Bar in 1883. In the office of Frederick B. Coudert, he became associated with Robert Ingersoll and established a life-long friendship with John W. Mackay, becoming personal counsel to Mr. Mackay and general counsel to the Mackay Companies and the Postal Telegraph and Commercial Cable Companies at 44 Wall Street.[14] Cook gained renown during this period as an authority on legal aspects of the railroads and the function of the Interstate Commerce Commission. His financial fortunes also prospered at this time as he made astute investments and shrewdly shepherded his resources as he amassed the significant wealth that enabled him to underwrite his philanthropic ventures at Michigan. The heartland virtues his father had enjoined as key to success—including morality, industry, and economy—evidently developed well within him.

On February 20, 1889, he married Ida C. Olmstead. The marriage was childless and short-lived, however, and the couple separated just five years later, on January 29, 1884. They were decreed divorced, June 8, 1898. Thus, at the age of forty, Cook, without direct heirs, was able to begin considering other creative uses for his time, energy, wealth, and idealism and how to realize more completely his father's prayer for his greatness. He had always been generous to members of his family, providing ready assistance for the education of any of them when needed and especially aiding his nieces with comfortable allowances. All of them were remembered with bequests in his will. The family tradition had been high-minded, however, and considered public service a privilege as well as a responsibility, particularly through the support of education. We have no record of what methods of fulfilling his father's hope Cook might have contemplated during the first decade of the century. Thereafter he made a few small gifts to hospitals (for example in 1911 and in 1913, at the behest of his nurse), but he had also humorously declined a request from a hospital for a substantial donation, saying that he was interested in helping people "from the neck up."[15]

In 1910 he was fortuitously contacted by Myrtle White (later Mrs. Godwin), financial secretary for the University of Michigan League of Women, who was soliciting funds from alumni for the construction of a women's residence hall on the Ann Arbor campus. She visited Cook's office in January of 1911. He responded to her plea and promised to contribute $10,000 to the venture. He also asked her to have Harry Burns Hutchins, who was just leaving his office as dean of the Law School to assume the presidency at Michigan, call on him. Hutchins took the occasion of a Michigan National Alumni Dinner in New York City on February 4 to respond.[16] The two found

an immediate rapport and set in motion the series of events that were to come to such marvelous fruition a bit later.

It was just at this time that Cook was establishing additional friendships critical to his future plans. He contracted with the firm of York and Sawyer in 1911 to build his town house at 14 East Seventy-first Street, launching a long friendship with Edward Palmer York, the senior partner of the firm. He also became acquainted with I. Elbert Scrantom of the Hayden Company, whom he liked and made responsible for the furnishings of the elegant interior of his Manhattan residence and for the interior decorating projects at his summer estate in Westchester County.[17] By 1912 Cook had decided to move well beyond his initial contribution to the funding of a women's dorm at Michigan and took on the private underwriting of the entire construction and furnishing of a residence, complete with park, for one hundred women. On February 20, 1912, he wrote Mrs. F. Mauck, who had just made a similar request for Hillsdale College, that she was too late. He had already committed himself to the Michigan dormitory project.[18] This dorm became the richly appointed Martha Cook Building, dedicated November 2, 1915. Construction was entrusted to architects York and Sawyer and its grand interior to Scrantom's Hayden Company.[19] Both of these firms were thus natural selections for later work on the Law Quad.

The forces of good fortune conspired in other ways to aid the gestation of the quadrangle. In his early conversations with Hutchins, presumably in 1911, Cook had talked of his interest in donating a second building, a dormitory for men.[20] He acquired property for that purpose, on Washtenaw Avenue, at the location of the present Exhibits Museum. He also confided to Hutchins, perhaps even earlier, that he wished to do something in his own professional area of interest and intended to include in his will provision for a professorship in the law on corporations. Although early discussions about these possible donations are not fully recorded (beyond a letter from Hutchins in 1913 indicating continuous exchanges), by 1914 they must have reached a stage of promise—promise that the male dormitory and law interests would meld and synergize—because at that time Hutchins seems to have given a confidential alert to Henry Moore Bates, suggesting that he write Cook.[21]

Bates was the very able successor to Hutchins as dean of the Law School (1910–39). Bates was from Chicago. He had a law degree from Northwestern and a literary, doctoral degree from Michigan and had taught as a visiting professor at Harvard Law School. He brought his supple mind, his enormous analytical ability, and his consummate tact, along with his ambition for the Michigan Law School, into full play with the proposed building project. He

was very like Cook in considering a new physical plant critical to the future of law at Michigan. Although the Law Department was founded in 1859, its expansion had been restricted by totally inadequate housing in the building at the corner of State Street and North University Avenue. Bates had had experience in librarianship and was particularly intent on the enlargement of the law library as requisite to future growth. He was thus like Cook in his concentration on this goal and in his conception of it as worthy of his concerted effort. For both, it was a mission. In one of his letters, Bates referred to the new Law School as "the cause to which I have devoted my life."[22]

Following Hutchins's suggestion, Bates wrote to Cook on December 5, 1914, that he would like to invite him to contribute an article to the *Michigan Law Review*.[23] On the seventh, Cook wrote in reply that he could not spare the time. Even though there was no immediate result from Bates's letter, contact between the two was thus established. The war intervened, putting all building projects on hold, but Cook's interest in Michigan did not abate. In 1917 he presented to the regents the gift of the park for the Martha Cook residents, having purchased the adjacent property, had its housing razed, and had its planting supervised by Samuel Parsons (landscape architect of New York, who, along with Olmstead, had laid out plans for Central Park).[24] Near this time, or shortly thereafter, Cook must have been already conferring with Edward York about a future quadrangle at Michigan, as the estimates Cook had drawn up for his Ann Arbor "quadrangle" date from March 1, 1919. They were prepared at York's behest by Marc Eidlitz, the famous contractor for the Harkness Memorial buildings at Yale.[25]

Early in 1920 Cook suffered the loss of his brother, Chauncey Ferris Cook, who died on February 5. Cook attended the funeral in Hillsdale. Hutchins sent a letter that was read at the ceremony.[26] Shortly thereafter Cook's own illness was remarked on by others in the correspondence stream.[27] Though Cook himself never mentioned his health, he was aware that his time was not unlimited. He referred, at least once, to the hope that he should live long enough to complete his work on the Law Quad, a hope principally realized by the time of his death on June 4, 1930. Much of his work was accomplished in just ten years. Fortuitously, a decade earlier, in 1920, all was propitious: the war was over, the economy was thriving, and the powers of Cook, York, Bates, and Hutchins were still at their height. The prospect of a Law Quad was ideally positioned to materialize. Awareness of Cook's illness (reputedly tuberculosis) must have given some edge to the urgency of the project. It moved at an awesome, ceaseless pace, its momentum culminating during 1929 and 1930, the last year of the decade and the year of Cook's death.

Cook had insisted on anonymity throughout this period. From the very first he was intent that his name not be given out. He wished no public announcements to refer to him. At first he had also stipulated that his name not even be mentioned during the regents' proceedings, which occasioned some awkwardness. This abhorence of publicity had manifested itself with his first dormitory gift in 1915, though the donor's name in this case could hardly be kept secret indefinitely, considering the carved inscription over the entryway naming his mother, Martha. Cook's persistent anonymity during the early years was part of a pattern evident in all his donations of the 1920s. He eagerly gathered accounts of his gifts that were published in numerous newspapers and journals around the country. He employed a clipping service for this purpose, and he carefully preserved the articles, particularly those accompanied by illustrations, including their brittle remains in the material he wished conveyed to the university's archives at his death. Although he did not hesitate to distribute to his friends copies of these public lauds touting his benefactions, he continued to require that Michigan's publicity regarding his ventures make reference only to "an alumnus" of the university.[28] Of course such secrecy did not hold. The Law School buildings were ultimately praised by the journals in the most hyperbolic terms, such as the comment on them as constituting an unprecedented "Law City," yet Cook knew them only from his photographs and the newspaper rotogravures. The original renderings and preliminary drawings made for him by York and Sawyer were also much prized by him. He had them framed and hung in his home, where he showed them to guests. To our knowledge, however, he saw none of the buildings with his own eyes.[29]

Although his reluctance to visit Ann Arbor can be explained in large part, though not completely, by his illness, an analysis of his strong desire for anonymity is more difficult. Cook was understandably hoping to avoid some of the nuisance that philanthropy surely brings to benefactors beset by constant appeals. Not only would such appeals be a bother, they would also threaten his concentration on this one large effort. As the second phase of the project was about to be announced in April, 1929, he wrote to Hutchins, "I consider philanthropy cheap, common, and vulgar, to say nothing of the annoyance of a flood of applications for donations." And there was the pride he could take in his posture of modesty. It was a heartland virtue, to do much but to do it quietly. His own austerity, and his adherence to his father's injunction about morality, virtue, industry, and economy, were lodged deep within him. He was fond of quoting Emerson in this vein ("A man of the world performs much and promiseth not at all").[30] Not only was he made

uncomfortable by publicity, it also carried a certain moral taint: in 1921 he wrote to Hutchins, "I have escaped so far the American disease of getting into the limelight and I am old enough now to be immune."[31] His was a nobler spirit. He would honor his parents but not seek publicity for himself. He had refused twice the proffer of honorary degrees from his grateful university, and he declined as well an invitation to speak at the 1930 commencement.[32] In 1922 he had written to Bates that he was glad not to be put in a class of undesirable philanthropists and hoped that he might convince others that there was no self-seeking or advertising or ulterior purpose in his benefactions ("What a man accomplishes in an intellectual way is rarely talked about but brick and mortar do appeal to the public").[33] He must have feared that his benefactions would seem like such self-seeking. Defensively, he responded to Hutchins, following a comment from an acquaintance who believed that philanthropists gratified their vanity at the expense of their heirs, saying that he, Cook, despite hearing such words, had himself that very day signed the contract with the Starrett engineering firm, contractors for the first Michigan building phase, indebting himself over $1,000,000 in this first leap on behalf of the university.[34]

Could he have supposed that his insistence on public anonymity, his reluctance to visit Ann Arbor, and his apparent modesty could have positive value? Self-abnegation meant the awe generated by his project could be tranferred elsewhere. In 1921, when Bates brought up the question of the naming of the buildings, the presumption being that they would be named for Cook himself, Cook answered, "It is hardly appropriate that a great Law Building should have a personal name."[35] In Cook's mind, the project was bigger than any one man, and such a dedication would only detract from the monumental effect he hoped to achieve. Above all he wished to succeed with his objectives. He wished to put the Michigan Law School into the first rank, on a level with eastern rivals such as Harvard and Yale, and he was aware that one could elevate the status of an institution through the uses of art. But he knew that this was not enough, that there must also be a large endowment to attract world-class faculty, that there must be special funds for distinguished visitors and support for a journal (the *Michigan Law Review*), and that above all there must be ample funding for legal research. Along with the thought given to the buildings, he spent much time devising plans for the underwriting of these other needs, viz., using the royalties from his publications to establish trust funds for them. His emphasis on legal research evinced itself in the name he required for the library (which was to be known and is known today as the Legal Research Building), and in some of his

stipulations about its arrangements. He believed that he, and through him Michigan, was the first to promote legal research to the extent of creating a full professorship devoted to such study. He had worked out a scheme whereby the buildings themselves, namely, the dormitories and the Lawyers Club, according to his reckoning, would provide profits in support of this chair. The first Professor of Legal Research was to be Henry Wade Rogers, the great judge, alumnus, and former Dean of Law at Michigan. The announcement was made at the first dedicatory exercises, but Rogers died before he could assume the chair. Subsequently, Edson Read Sunderland was appointed to this distinguished position and became the actual first Professor of Legal Research. In this chair, he was not to teach but to spend all his time on research, wrestling with the weighty legal problems that beset the nation.[36] Cook's goals thus extended beyond the quadrangle, Ann Arbor, the state of Michigan, and the legal profession to the nation itself. He believed that by improving the character of the Michigan Law School and thus the American Bar, he would consequently influence beneficial change in America at large. There are numerous references to his purpose, for example in a letter to Regent Sawyer, "While I have a definite purpose, namely to improve legal education and the legal profession, . . . ," and in a letter to York, "I would like to have the inscriptions show the motives causing this building."[37] His inscriptions (Appendix A), such as THE CHARACTER OF THE LEGAL PROFESSION DEPENDS ON THE CHARACTER OF THE LAW SCHOOLS. THE CHARACTER OF THE LAW SCHOOLS FORECASTS THE FUTURE OF AMERICA, and UPON THE BAR DEPENDS . . . THE PERPETUITY OF THE REPUBLIC ITSELF, spell out these ideals. He must have also supposed that if he were successful in achieving such objectives, his work would be immortal. To accomplish such goals, he knew his resources must be concentrated. They could not be squandered. He was wealthy, but his wealth was not unlimited ("I am not the Bank of England"), hence his careful monitoring of the expense of every step along the way. In the hard-driving, disciplined Michigan manner, as solid and as austere as the frontier ("with morality, virtue, industry, and economy"), he pursued his ideals. The aura of a certain amount of secrecy, eccentricity, and mystery could be useful.

It could also give him a freer hand. Cook was by nature somewhat diffident. It was more effective and rewarding for him to direct the proceedings from his desk and Miss Laubenheimer's stenographic pad than to jump into the fray of face to face discussion, where he might lose control. In effect, he directed by letter. This is not to say that he shunned subjecting his ideas to debate. He debated them in his letters, with long discourses in which he took

up each point of an argument. This was as true for his letter-discussions with associates in New York as for those elsewhere—judges, justices, regents, his own legal counselor, and his friends. But, if the project were to continue, final decisions must always be his. Had he been more inclined and able to travel and fraternize in Ann Arbor or to leave much of the business to others, we would not have the correspondence stream that survives and we should not be able to reconstruct the sequence of these events and the thinking that prompted them. Nor could we then discern so clearly the motivating forces of Cook's "movement."[38]

The lure of the unknown was a gain that came from relatively slight sacrifice. It was a shrewd course. It allowed Cook to follow his doctor's orders and retire to his estate at Port Chester. He could dictate letters there just as easily as in Manhattan. Those who knew, knew. Those who did not know would know in future. Before his death, he arranged his papers, including full correspondence, all specification books, contracts, certificates, receipted bills, and audits, for donation to the university archives. The future would tell his story. He must thus have been aware of the additional force his remoteness and mystery added to his cause, and he remained an almost mythical figure to the end.

NOTES

1. Michigan Historical Collections, Bentley Historical Library, University of Michigan, The Law School (MHC), 59-3, letter of June 15, 1925. Dean Alfred Lloyd, Acting President of the university and presiding officer at the dedication, also used the term *mythical character* in referring to Cook. "The Dedication of the Lawyers' Club," *Michigan Alumnus* 31 (1924): 754. For the engraving: MHC, photo collection; W. C. Moffatt, A. C. Hass, C. Wayne Brownell, eds., *A Book of the Lawyers Quadrangle* (Ann Arbor, 1931), frontispiece.

2. Creighton's letter:

The University officials would like to have one of your photographs to include in the bound volume, and Mr. Bates, as their spokesman, has asked me to obtain one from you. The book will also have some cuts showing the building.

I thoroughly appreciate your modesty regarding the Lawyer's Club, and know in advance that you will object to furnishing the photograph, but if you could bring yourself to it, I believe it would not only give pleasure to the students and alumni, but also would add a proper touch of humanity to the record of the dedication of the buildings.

I haven't given up my idea of prevailing upon you to have an oil painting done, and sometime when I find you in just the proper humor, I am going to press it. You owe it to everybody.

Cook replied on February 25 that he had no photo he could send. See also Dean Bates's letter of January 26 to John Creighton requesting the photo. University of Michigan Law School Archives (UMLSA), February 10, 1926.

3. There are two castings of this, one in the Martha Cook Building and another, installed shortly after Cook's death, in the Reading Room of the Legal Research Building. UMLSA, fall 1930; Marion L. Siemons, *A Booklet of the Martha Cook Building at the University of Michigan, A History of the First Twenty Years* (Ann Arbor, 1936), frontispiece.

4. Questions regarding Cook's social philosophy, which would surely seem to modern readers to be dated if not antediluvian in its ethnic bias, are best taken up by social historians, and there is no intent to pursue them here.

5. *Addresses Delivered at the Dedication of the Lawyers Club of the University of Michigan, June 13, 1925* (Ann Arbor, 1926), pp. 3–4.

6. Emma Laubenheimer was Cook's faithful secretary for thirty years. See her brief comment regarding Cook's dream, "In Appreciation," *The Lawyers Quadrangle* (1931), unpaged. E. M. Trotter also served as sometime secretary to Cook. His secretaries often worked with him at his home on Seventy-first Street and later at his Port Chester estate.

Cook's reclusion late in his life was in large part necessitated by his illness. Before that, his social activities were many and varied. Among his papers is preserved his certificate of life membership in the Kane Lodge (dated April 27, 1900). There are also a number of references in his letters to the Bloomingrove Club, where he enjoyed outings, particularly in his earlier years. He liked to hunt ruffed grouse in this Pike County, Pennsylvania, preserve, where the hunting and fishing club he belonged to had a wilderness spread of 20,000 acres. Though he was only able to get away there for a few days at a time, some of his letters were sent from there. His letters also indicate that he enjoyed inviting friends there. On his doctor's orders, he spent increasing amounts of time, particularly after 1921, at his Port Chester estate, a home of some ninety-seven acres, overlooking Long Island Sound, near Rye, New York. Cook kept horses there for riding, which he enjoyed. He regularly received guests there, sending his driver to pick them up from the train station. York, a particularly frequent visitor, came often to discuss the Michigan project. Other members of the York and Sawyer team, as well as Hutchins, President Burton, and others from Michigan, were also received there, as were his social friends, such as the Creightons and the Mackays. In John Creighton's brief, written at the time of Cook's death, there is a description of Cook's delight in his gardens there. Cook had invested more than $60,000 in specimen plantings, many brought from exotic Asian sources. Rhododendrons and roses were among his favorites. Cook knew all the Latin names for them and was pleased to point them out to guests. When the weather allowed, he also dictated letters there.

7. Henry M. Bates, "The Evolution of the Law Quadrangle," *A Book of the Law Quadrangle at the University of Michigan*, ed. N. Fred, A. B. Dieffenbach, and H. W. Fant (Ann Arbor, 1934), pp. 11, 23–29; York, MHC 59-7, October 29, 1924.

Bates wrote a number of articles on the quadrangle, including: "The Lawyers

Club and Dormitories," *Michigan Alumnus* 29 (1922): 307–9; idem, with G. C. Grismore, and E. B. Stason, "The Law School," *Michigan Alumnus* 35 (1928): 243–51.

8. Regents Proceedings, April 28, 1922, January 11 and April 26, 1929; William W. Cook, "A Letter to the Lawyers Club," *Michigan Law Review* 24 (1925): 34.

9. Siemons, pp. 6–7. These daguerreotypes have passed to the collections of a descendant, Ann Bradford Cook.

10. John Potter Cook's first wife, Betsey, was Martha's sister; she had died at the age of thirty-six in 1850. Of the children of this first marriage, who were reared together with the second brood, a daughter, Martha (Martha became Mrs. Keating of Muskegon), remained in long association with Cook.

11. *History of Hillsdale County, Michigan* (Philadelphia: Everts and Abbott, 1879), p. 94; M. Ferguson et al., *150 Years in the Hills and Dales*, vol.1 (Hillsdale; Hillsdale County Historical Society and the Hillsdale County Bicentennial Commission, 1976), pp. 260–61.

12. The house had been built by Joel Wheaton. It was professionally landscaped by S. Simon from New York. The house passed to Cook's brother, Chauncey Ferris Cook, then to Cook's nephew, Chauncey Ferris Cook, Jr., and his wife Jane Whitney and their family, the last Cook occupants. Ann Bradford Cook, one of the two daughters of this last family, also has in her collections a contemporary engraving illustrating the planning of the garden's plantings. The house was owned later by Dr. and Mrs. E. M. Malcheff, and it now serves as the Delta Sigma Phi fraternity lodge. A. Elliott, *Buildings and Views, Hillsdale County* (Hillsdale, 1989), pp. 11, 33–35; V. Moore, "Live in Homes of Historic Interest," *Hillsdale Daily News*, August 30, 1961, 33; K. Dawley, "Hillsdale Area Felt the Influence of John P. Cook, A Pioneering Giant," *Hillsdale Daily News*, June 11, 1974, 33–37 (who indicates that John Potter Cook was born in "Plymouth, Chenango County, New York," of Joseph and Lydia Cook). Hillsdale recognized the pioneer's public service by naming Cook Street for him. His obelisked and pedimented tomb can still be seen at the center of the Cook circle in the Hillsdale cemetery. L. Hawkes, J. Northrup, K. Dawley, *Cemetery Records of Hillsdale County, Michigan* (Hillsdale, 1983), no. 786.

13. He was at Hillsdale for two years, according to his letters to Regent Sawyer. UMLSA August 23, 1923; MHC 58-13, October 1, 1923. In the latter he notes that "small colleges have not the equipment" Cook frequently referred to his admiration for Judge Cooley, who had been his teacher at Michigan as well as his father's counselor and friend. Creighton, *Addresses*, p. 3; Siemons, p. 4. In the Cook family, Cook's brothers Chauncey and Franklin both studied law at Michigan. John Bradford Cook, Franklin's son, Florentine, Chauncey's daughter, and Ann Bradford Cook, Chauncey Jr.'s daughter, among other descendants, also earned Michigan degrees. Franklin served as a regent.

14. MHC 59-13, November 19, 1913, and October 26, 1914; Siemons, p. 2; *A Book of the Law Quadrangle*, p. 11 (re: "William B. Coudert's" [sic] firm); "The Lawyers' Club, a Gift to Posterity," *Michigan Alumnus* 31 (June, 1924): 100. Howard H. Peckham, *The Making of the University of Michigan* (Ann Arbor, 1967), p. 121, attributes Cook's wealth to investments in Cuban sugar and street railways.

15. MHC 58-3; 59-13.

16. Shirley W. Smith, *Harry Burns Hutchins and the University of Michigan* (Ann Arbor, 1951), pp. 225, 304; Siemons, p. 10; Bates, *A Book of the Law Quadrangle*, p. 23; Myrtle White Godwin, "William Wilson Cook," *Michigan Alumnus* 36 (August, 1930): 715–16.

17. Years later York suggested to Cook that, as he had intended to bequeath all his personal property such as objets d'art to Michigan in his will, when he retired from his Seventy-first Street home he might have the boiserie paneling from his private, personal library there transported to Michigan to be fitted into a special room in the Legal Research Building. "World's Finest Educational Building," *Michigan Alumnus* 37 (April, 1931): 264. Blueprints of the original plans of 1912 survive in the university's archives.

18. MHC 59-13.

19. The working drawings, executed between April, 1914, and June, 1915, are preserved in the university's archives.

20. Bates, *A Book of the Law Quadrangle*, p. 23.

21. Ibid.; Elizabeth Gaspar Brown, with William W. Blume, *Legal Education at Michigan 1859–1959* (Ann Arbor, 1959), p. 311; idem, "The Law School and the University of Michigan, 1859–1959," *Michigan State Bar Journal* 38 (August, 1959): 16–28; Earl D. Babst, "Dr. Hutchins Paused Over the Name of William W. Cook," *Michigan Alumnus* 36 (June, 1930): 646. The Law Department became the Law School by act of the regents, January 21, 1915.

22. Bates, MHC 58-10, June 29, 1921. Bates also received a number of honorary degrees. Henry W. Rogers, "Law School of the University of Michigan," *Green Bag* 1 (1889): 189–208.

23. It is not without interest that Cook preserved this letter. MHC 59-13.

24. Siemons, pp. 13–14. These were actually carried out during the spring of 1921. Hutchins, MHC 60-22, March 23, 1921.

25. MHC 59-7. See the references to Eidlitz in the next chapter and the discussion of the Yale buildings in chap. 6.

26. Hillsdale County Historical Society, Obituary File.

27. MHC 59-7, May 29, 1920 (York), 60-22, June 30, 1920 (Hutchins).

28. Cook wrote to *The Michigan Alumnus* indicating that he had not received a copy of the relevant issue (with the first big story about his buildings) and added that as he was a subscriber, he would like one. MHC 59-9, November 16, 1924. On December 10, 1924, he wrote again, asking for ten additional copies.

29. Walter H. Sawyer, "William W. Cook, University Benefactor," *Michigan Alumnus* 36 (June, 1930): 643–46. Sawyer was a regent of the university and a friend of Cook. He describes his attempt to persuade Cook to visit Ann Arbor to view his buildings and Cook's refusal. Cook purportedly said, "No, Doctor, you cannot persuade me. You want to spoil my dream. I never shall go to Ann Arbor." Although Cook preserved his correspondence with Regent Sawyer, such a letter is not included in these files. MHC 59-4. Cook's secretary, Emma Laubenheimer, also refers to "Cook's dream." See n. 6.

30. MHC 60-22, April 15, 1929, 58-6 and 60-22, September 14, 1921.

31. MHC 58-10, August 13, 1921.

32. Siemons, p. 5.

33. MHC 58-10, March 9, 1922.

34. MHC 58-10, May 4, 1923.

35. MHC 58-10, December 27, 1921. He was willing to have a discreet tablet (in very shallow relief, embossed on a simulated unfurled scroll) carved over the entrance to the Lounge of the Lawyers Club naming him as the founder, but he did not want it visible at the time of the dedication. He had fussed over its wording, changing the final form from the "New York" to the "American" Bar: THE LAWYERS CLUB FOUNDED APRIL 1922 BY WILLIAM W. COOK AB 1880 LLB 1882 OF THE AMERI-CAN BAR. MHC 59-7-7, February 18 and June 2, 1924. The university installed a tablet in the Legal Research Building crediting Cook with the donation of all the buildings of the quadrangle after Cook's death in 1930.

36. Cook was furious when Harvard claimed to have established the country's first legal research professorship and wrote a stern rebuttal that caused some controversy. MHC 58-4 and 58-12.

37. UMLSA August 23, 1923; MHC 59-7-7, February 7, 1924. This sentiment was expressed as early as June 1, 1921. MHC 60-22.

When York asked Cook if he would care to prepare texts of specified lengths for the tablets to be inscribed over entrances to the quad, Cook was exhilarated. He began his letter of response to York, who like himself had a strong interest in the classics, by quoting the opening lines of Homer's *Iliad:* "Sing, Goddess of the wrath of Achilles" Cook then proceeded to lay out his formulations for the inscriptions, which were all excerpts from his own writing, mostly taken from his letter of gift to the regents. These were statements that summarized the ideals prompting his benefaction. Cook's numerous revisions of the texts date from October, 1923, to April, 1924. Although Cook seemed very confident at first about their didactic character, he consulted others about them, as he usually did, and then became uncertain when he received some criticisms about them, such as an attack on his grammar (this involved a classic conundrum about the correct verb form required by single and compound subjects and brought a riposte from Cook: "these professors think too much") and a question from Bates about whether his choice of the word *steel* conveyed sufficient flexibility with regard to the constitution. President Hutchins asked whether *one* inscription would not be enough. Cook then became anxious about the whole idea of inscriptions and explained to York the importance of using them to indicate the "purposes of the buildings." He recollected inscriptions "all over the buildings" at Yale, where he said there were "all sorts of queer things" and that there was never any criticism of those. After a number of additional letters from York, in which York first explained that inscriptions were indeed in good taste, that they were often used by the York and Sawyer firm, and, in a short history of the use of inscriptions, that ancient Egyptians, Greeks, Romans, and others, had all made prominent and effective use of inscriptions and then concluded with the fact that James Gamble Rogers had used at least forty-nine inscriptions at Yale, Cook was convinced. "We will proceed

with the inscriptions," he wrote in February, 1924. These are, in a sense, verbal portraits of Cook's thinking at the time. UMLSA, MHC 59-7-7, 60-22, especially February 13, 1924.

38. Cook used this term to refer to his project in his correspondence, for example, in this letter to President Little: "That is the problem that will face your research professor That is the reason I started the movement at Ann Arbor in 1922, and that is the reason I am following it up now. The buildings at Ann Arbor are to carry out the idea. Otherwise they are mere exhibits." MHC 59-1, September 7, 1926. Cf. his letter of August 9, 1929 ("this is what keeps me alive"). MHC 60-22.

Determining the Site of the Quadrangle

With such a lofty mission in mind for the Law School, Cook wanted to be sure of a location that was prestigious by virtue of its attractive surroundings and its centrality. However, as the law project was not conceived in its full form from the outset but grew through the course of the 1920s and achieved its full extent only as a result of the particular interactions of Cook, York, Bates, and Hutchins that took place during those years, there was a series of vacillations concerning the matter of the site. As discussed in the last chapter, Cook was interested in doing "something" for law at Michigan, but it became something substantial only as the years unfolded.[1] By 1920 the form of the benefaction was not yet clear. Cook had unquestionably decided on the gift of a men's dormitory, and he had indicated that he would also provide something vaguely called a law building, presumably a classroom building, library, or both. The March 1, 1919, estimate he had Eidlitz draw up is entitled "Quadrangle Building," but that would have been a residential unit. Cook tentatively approved this large, 250-student dormitory on March 11, 1919.[2] Almost a year later, in February, 1920, York wrote that he was conferring with Scrantom about Cook's "quad," which was to house 252 students, and that he had sent him some drawings to enable him to prepare an estimate for furnishings.[3] Late in the same month, Hutchins wrote Cook, referring to the proposed dormitory and saying that he planned a visit with Cook in New York on the twenty-seventh for further discussion. This was just a little after the election of Marion Leroy Burton to the presidency of the university, which meant that Hutchins could finally retire from the office he had held since 1910.[4] It also allowed Hutchins more time to pursue his hopes for new law school buildings. He continued personally to monitor all matters regarding Cook. When York sent Cook some perspectives in May, 1920, he referred to Cook's "proposed quadrangle at Ann Arbor." When Hutchins conferred

with Cook by letter in June about the proposed site for Cook's project at Washtenaw and Volland Streets, he referred to it as a "boys dorm."[5]

Discussions continued between York and Cook during the rest of 1920 and into the early months of 1921. During this period, in Cook's thinking, the men's dorm metamorphosed into a law students' dorm, or Lawyers Club, and it was to be associated with a law building. Though we do not know exactly how and when this conjunction took place, Hutchins clearly aided the development of the idea. In May, 1921, he wrote to Cook of his enthusiasm over Cook's plan, particularly with the part of it that provided support for emphasis on legal research. Hutchins reported that he had discussed the plan with Dean Bates, who was pleased to learn that Cook's intentions took such a course and was particularly delighted that Cook contemplated a new law building. Bates presumed this would be a fire-proof structure in which the library could be secure. As to location, it could be on or near the lot on which Cook wanted his building for the Lawyers Club, formerly conceived simply as a men's dormitory. Although Cook must have decided on this change much earlier, in July, 1921, he repeated to York and Sawyer his resolve to have the new dorm for law students instead of "lit" students and to call it "The Lawyers Club."[6]

There were also some discussions during the spring of 1921 that suggest explorations into matters of architectural style. Cook sent York news clippings regarding the Collegiate Gothic dorms and other structures going up at Princeton. Singled out for mention were those of Day and Klauder, which followed Oxford and Cambridge closely, and R. A. Cram's quadrangle for the new School of Architecture. In May, Yale's buildings, particularly a large dining hall, in Gothic style, were noted by Cook and York in their exchanges.[7]

Hutchins had already talked with Bates about developments with Cook's plans in April and had asked Bates to draw up a formal statement outlining their potential benefits for the Law School. Bates did this in an eight-page letter to Hutchins dated May 25, 1921. In it Bates explained the dire need and compelling rationale for a new law school. He was enthusiastic about Cook's tentative plan for a "lawyer's club" as a dorm for law students, especially if built in conjunction with a new law building. He thought these two buildings might be in close juxtaposition, yet relatively separate from the main campus. This would foster esprit de corps among students, enhance their ready use of the library, and, by minimizing distraction, strengthen their powers of concentration. He also agreed with Cook's idea of using profits from the residence hall for the support of legal research, an area theretofore neglected. Bates seemed to conceive of two buildings to house the plan, perhaps with a

court between them, or, he wrote, a quadrangle would also be interesting. As to style, if it were to be "Gothic," buildings in the style of Martha Cook would be attractive. He was himself studying the arrangements of law buildings in this country and the Inns of Court in England to be ready when the time should come. Hutchins forwarded this letter to Cook.[8]

In June, 1921, Cook wrote to Hutchins that he would begin the project as planned with a law students' dorm. He referred appreciatively to Bates's May 25 letter. He approved of the ideals Bates articulated in it, particularly those that went beyond "brick and mortar." He promised to help as much as he could but feared that the plot of land he owned would not accommodate both a large dorm and also a law building. He asked Hutchins to show Bates the York and Sawyer plans drawn up for him earlier.

Cook had acquired real estate near the intersection of Washtenaw and North University, where the Exhibits Museum is today, that he considered premier for the location of his dormitory quad. He referred to it as the "Hall" property. It was bounded by Washtenaw, Geddes, and Volland Streets, forming an irregular polygon (fig. 8). Eidlitz's revised estimate of 1919 had mentioned that the "Quadrangle Building" Cook intended for this location could be extended on Geddes and Volland Streets.[9] By the time of Cook's resolve to build the Lawyers Club, Hutchins was attempting to persuade him to move to another location. Cook agreed that the Hall property was not large enough, but he considered the location excellent. At first Hutchins presented the possibility of adding land, bounded by Belser, Volland, Observatory, and Fourteenth, near the Hall property (C, fig. 8). York had counseled against this additional plot, noting its distance from Washtenaw and the disadvantageous fall of the land there. Then Hutchins suggested the block east of Hill Auditorium, in effect where the Michigan League is today (A-B, fig. 8).[10] Cook was not at all inclined to follow either of these suggestions. He considered the plot on North University "obscure." Even if augmented with an additional plot to provide for the law building, such a location would detract from the distinctiveness of his plan for the dormitory, the Lawyers Club, and diminish its architectural beauty. Cook quoted York, saying that in this location the Lawyers Club would be overshadowed from the south (by the law building) and the whole would be out of harmony with the surroundings. Cook's project required a prominent place for a prominent subject, and Cook considered the Hall property on Washtenaw a first-class location. Its distinctiveness was essential to the beauty of his plan. If engineering shops were gathering in the area, they should simply be shooed away.[11]

Hutchins pressed Cook, noting that the university intended an extensive

building program over the next two to three years and that it was essential to stake a claim to space for new law school quarters.[12] Although Cook was standing firm on his preference for the Hall property, in August Hutchins took a new tack, with some compelling new arguments. He now suggested that Cook consider relocating the project to the south side of the campus, on the block immediately to the west of the Martha Cook building. That would put it near the General Library, in proximity with other buildings used for classes that were to a considerable extent elected by law students, and directly opposite the soon-to-be-erected Clements Library of Americana on South University. At the end of the letter, he added a sentence in which he quoted Mrs. Hutchins's enthusiasm over the beauty of the shrubs and gardens of Martha Cook following a recent visit. Cook responded that he "hardly like[d] the idea of the [proposed] Law Building being across the road from the Martha Cook" residence.[13] In this same August, 1921, letter, Cook clung to his Washtenaw-Volland Street site, suggesting that his project might expand across Washtenaw, so that the law building would be sited on the irregular block bounded by East University and Church Street. The reply of Hutchins was that this site was already intended for the new medical building. This answer roused Cook's competitive fervor, and he expressed his consternation that law should be shoved aside by the "medics" and the altogether too-grasping sciences. He threatened to lose interest in the project if so marooned and suggested that the medics might be told to move along, farther south on the avenue.[14]

Hutchins instincts were right on course. On September 2, 1921, he wrote Cook a critical six-page letter. Maps and blueprints were to be appended and were sent under separate cover. He delineated the serious objections to locating the law project on the Hall property at Washtenaw:

> Within the past few years conditions on Washtenaw Avenue have greatly changed. Instead of being the quiet avenue of a few years ago, it has become one of the two most crowded thoroughfares of the city. It is the direct through auto route from Detroit and autos are constantly passing. The condition would not be so bad, were it not for the auto-trucks. It may be difficult for you to visualize this, as you have not been here recently, but these trucks are now almost constantly thundering by on this avenue. This nuisance has come within the past year or two and is on the increase. A large part of the freight from Detroit to Ann Arbor and the small places west now goes by auto-truck, and the probabilities are that this kind of traffic will be

greater in the future. The result of all this is to make the avenue both noisy and dusty, and the corner in question undesirable for class-rooms and lecture-rooms, particularly in summer. . . . The shape of the lot in question does not seem to me well adapted for a law build-ing whose lecture-rooms and library-rooms should preferably be rec-tangular in form. Furthermore, if the new Law Building [sic] is on this lot, it will have as its immediate neighbors only buildings de-voted to science . . . Engineering . . . Medical . . . Dental . . . Chemical Building[s], Natural Science . . . Hospitals . . . [of] little architectural excellence To get the necessary light for laboratory purposes, they are usually of factory construction, all windows and ugly

I wish that you and your architects could be here for a day to look the situation over and give us the benefit of your judgment, informed as it would be by actual observation and study on the ground. It is so important that no mistake be made now that I am anxious that all the facts bearing upon the situation be understood and fully consid-ered by those whose opinion will be controlling. I am quite confident that the personal inspection suggested would lead you to conclude that the block immediately west of the Martha Cook Building would be the place for the new Law Building. And I should hope that it would lead you also to conclude that the most desirable place for the Lawyers Club would be either in this block or in the block immedi-ately west. . . . I think the north half of the block at the corner of South University Avenue and State Street the ideal place; . . . [it would be] larger than the Hall plot The Regents are purchasing these blocks for future development So located, the buildings would be away from heavy public traffic, near the Literary College, the General Li-brary, the Clements Library of Americana, the Alumni Memorial Hall and the Michigan Union. With the Martha Cook Building they would form a remarkable and distinctive group. . . .[15]

Although Cook did not intend an inspection visit, and the maps men-tioned were not yet in hand, his ability to visualize this proposed new site was keen. His reply is dated only four days later, September 6: "Your sugges-tion . . . appeals to me." The noisy, dusty argument had hit home. That would be no place "to sleep or converse," Cook wrote, and "factory buildings would not help general appearances." He had one concern: that there be a court for the dormitory. The following day, September 7, he asked York to evaluate the proposed change to the South University site, saying that if the

university would set aside the two requisite blocks, bounded by South University, Tappan (formerly Ingalls), Monroe, and State Streets, that he would consent. He revealed his enthusiasm for the change with the line, "You will see there are great possibilities ahead." York responded the next day, September 8, saying that this new site was a much better location, being "more accessible to the literary development of the University." By the eighth the maps and blueprints intended as illustration for Hutchins's critical September 2 letter had also arrived and had further stirred Cook's interest. He wrote that same day to Bates and Hutchins, including in his letter some complimentary comments about Bates's accomplished professional standing, and indicated that, in accord with the "wonderful layout" sent by Hutchins, he was contemplating four buildings, two of which would be dormitories (one for Junior Laws and one for First Year Laws). There would be a main club house on State Street and South University Avenue for about 100 Senior Laws and dining space for about 300. The smaller size of this first dorm would mean he could build the Law Building that much sooner. He considered Bates and Hutchins to have made a "ten strike" with the new location. In only one more day, on September 9, 1921, Hutchins wrote Cook of his delight: the new buildings along with Martha Cook would form a "distinctive and remarkable group . . . that would not be surpassed or equalled on any university campus in the country." The plan could include the entire fronts on South University so that there could be a court for the Lawyers Club. It would be a true quadrangle. He requested a formal statement from Cook, for presentation to the building committee, to the effect that Cook would erect these buildings provided the sites were furnished. Bates was sure to be delighted when he returned from his vacation. Indeed, Hutchins had immediately sent the contents of Cook's earlier letter on to Bates. Cook promptly responded with the statement requested by Hutchins. The building committee was unanimous in accepting the proposal and recommending it to the regents. Hutchins sent Cook the good news by telegram, September 19, and Cook wrote back, September 21, that he was having York and Sawyer do some sketches and that they were getting up "something wonderful."[16]

On September 30, 1921, the regents acted favorably with regard to the new site, and Hutchins confirmed this with Cook. Plans were laid for Bates and Hutchins to travel to New York later in the fall to confer directly with Cook about particulars. Cook asked York to move speedily to prepare sketches for that meeting. York wrote on October 10 that the quadrangle would be an "interesting problem and we hope to get a great deal of pleasure out of designing it."[17] The project was now fully underway.

Hutchins's success in this series of maneuvers is interesting. He marshaled a formidable number of arguments, particularly in the letter of September 2, all geared to specific aspects of Cook's character: Cook's loathing of the vulgarity of crowds, dust, and noise (Washtenaw truck traffic); his interest in quiet (State Street being away from public thoroughfares); his distaste for the sciences (engineering and medicine as neighbors); his taste for beautiful buildings (Alumni Hall versus the ugly, factory look of the science buildings) and gardens (Mrs. Hutchin's remark about the Martha Cook plantings); his liking for prominence (near the General Library, Literary College, Union, Alumni Hall, etc.); his desire for the professional prestige of law (the Hall plot as too small); and his competitive spirit (rivalry with another benefactor, Clements, who was making a large gift across the street). A special asset was pointed out by Hutchins. Instead of the irregular shape of the Hall property on Washtenaw, the two blocks of the new site would be a regular rectangle and would accommodate Cook's vision of a central courtyard. It would be a true quadrangle. Finally, Cook's anxiety for the future was well understood by Hutchins ("important that no mistake be made now"). Hutchins had already made it clear that time was running out. Within the month, the regents would decide on the plan for the campus that would be determinative for the indefinite future. A claim to space for a new law school must be staked now. Flattery and appeals to vanity were also implicit and must have been persuasive. Hutchins's follow-up letter of the ninth claimed that Cook's buildings would form a remarkable and distinctive group, one that would not be surpassed and probably not equalled on any university campus in the country.[18] Such inflation might be justified. It went a long way; indeed, the sum of the arguments went all the way to their mark.

For Cook's part, his character traits had also won him a "ten strike." His tenacity regarding the Hall property, his insistence on attractive surroundings and centrality, and his use of his trump card (his threat that he might just lose interest in the entire venture if he were marooned in an unacceptable way) had brought his project from the "cat-hole" lowlands beyond Washtenaw to the central intersection of the campus, to the site that York in his follow-up letter called "the finest in Ann Arbor."[19] Cook's shrewdness throughout this entire period of negotiation, which may be thought of as extending from the time of Hutchins's first visit to him in New York in 1911 until this determination in 1921, was that he insisted on building his Lawyers Club or men's dormitory first, holding the law buildings for which the university was most eager for subsequent campaigns. Although a library, classrooms, and accommodations for administration were all to be included within

the ultimate quadrangle, the sequencing was not ideal from the university's point of view. This was Cook's ultimate trump card. It gave him extraordinary control over procedure.

It was a risk. In 1921 Cook was sixty-three; he had retired from daily practice; and although it was kept confidential and Cook was still vigorously producing legal publications, he suffered from serious illness. There were moments when Bates worried that he should ever see his expected library and classroom building. In the woeful circumstances of his present law school quarters, he valiantly held on, yet books were piled in mounds, acquisitions had perforce to be limited for want of space to contain them, and facilities for both faculty and students were seriously cramped, hampering growth and vitality on all fronts. Hutchins must have realized that it was a bold move to proffer the greatly enlarged site, yet Cook might rise to the enlarged opportunity. Hutchins might thus seal Cook's developing ambition to underwrite an entire new law school. Cook had moved cautiously, yet Hutchins must have seen that Cook's idealism would in the end be satisfied only by a large ensemble of buildings that would be distinctively separate yet prominent and that would form a self-sufficient legal academy dedicated to Cook's high ideals of reforming the law and hence the character of the nation. Once it was clear that Cook intended to will his large estate exclusively to the university for such law-school purposes, the risk was clearly worth the gamble. The process would certainly be interesting, for Cook was undeniably unlike most major donors: he intended to concentrate his entire financial and personal capacity, which meant his huge fortune, his brilliantly precise mind, and his forceful personality, on this one enterprise.

By the first of October the venture was well launched. Cook was drafting his will as well as his letter of gift covering the first law donation. The site was determined. During October and November Dean Bates deeply involved himself with the planning by busily surveying law schools across the country and studying the academic planning on major campuses. In answer to his queries, he was repeatedly advised to look at the handsome Princeton quadrangles, the Princeton Graduate School, and the new Harkness Quadrangle at Yale ("the most glorious thing of its kind in the world").[20] He visited New York and talked with Cook and York. All seemed to be moving forward.

There was just one problem that threatened to undermine the ideal form of the proposed new quadrangle. As in any democratic situation, a project like this one was bound to provoke clashes of interests, a number of which would be displaced with the creation of this large new complex of buildings. Oakland Street bisected the site and would have to be closed, making a single

entity out of the two city blocks (figs. 8–9).[21] Although this might cause some protest, it was not foreseen as a daunting problem. More immediately troublesome were the buildings already standing on the blocks in question. Most of these were aged rooming houses that could be razed with relatively little difficulty, but there were two parcels of land along State Street with buildings that were not so easy to acquire and eliminate. On December 22, 1921, Bates sent a telegram to York and Sawyer asking that the sketching be stopped immediately pending a new development. He then explained by letter that a strip of land equivalent to two parcels along State Street should be excluded from the quadrangle's design. These were occupied by fraternity houses. Particularly critical were three fairly recently renovated, expensive houses. Certain alumni, some of them still powerful members of the university community, had strong, sentimental attachments to two of them. He recommended that the strip of land be yielded and the three houses allowed to stand. The design could be worked out around them (figs. 9–10).[22] When informed of Bates's proposal, Cook did not waver for a moment. He wrote to Bates that such a "gash in the plan" would be absurd and added, "You will be criticized for all time to come if you break up the comprehensive plan for your Law [School]." Cook was now thoroughly territorial. Hutchins, ever conciliatory, stepped in and mediated the difference. Accommodation was found for the houses to move across the street, and all was straightened out.[23]

The events surrounding the closing of the street were also dramatic. The condemnation proceedings were still underway as the contracts for construction were being prepared and they became final only days before the contracts were actually let. A telegram from Shirley Smith, secretary of the university, alerted Cook of the success immediately before his large financial commitment. The ousted residents then appealed. The matter was only resolved in Cook's favor just as "the dirt was flying" when the excavation began.[24]

<div style="text-align:center">NOTES</div>

1. Earl D. Babst, "Dr. Hutchins Paused over the Name of William W. Cook," *Michigan Alumnus* 36 (June, 1930): 646, says that Hutchins revealed to him in 1911 that Cook had "something in mind" in connection with the university.

2. MHC 59-7-1, March 1, 11, 1919; cf. York, MHC 59-7-1, April 3, 1919.

3. MHC 59-7-2, February 4, 1920.

4. Burton accepted the university's invitation on January 5, 1920. Shirley Smith, *Harry Burns Hutchins and the University of Michigan* (Ann Arbor, 1951), pp. 240–44; MHC 60-22, February 24, 1920.

5. York, MHC 59-7-2, May 29, 1920; Hutchins, MHC 60-22, June 24, 1920.

6. Hutchins, MHC 60-22, May 24, 1921; Cook, MHC 59-7-3, July 25, 1921.

7. MHC 59-7-3, March 5 and May 20, 1921.

8. MHC 60-22 and 58-6, May 25, 1921.

9. MHC 60-22, June 1, 1921. MHC 59-7-1, March 6, 1919. Volland Street no longer exists.

10. Hutchins, MHC 60-22-3, June 13, 1921; Cook, MHC 59-7-3, July 25, 1921; York, MHC 59-7-3, July 27, 1921.

11. Cook, MHC 60-22-3, July 28 and June 18, 1921.

12. Hutchins, MHC 60-22-3, July 14, 1921, regarding an appropriation of $5,000,000 from the state for building projects.

13. Hutchins, MHC 60-22-4, August 9, 1921; Cook, MHC 60-22-4, August 13, 1921. Cook's evident reluctance here exposes as romantic myth the oft-heard notion that he aimed to have his parents eternally united via their memorials on either side of Tappan Avenue. In 1929, the dormitory dedicated to his father, John Potter Cook, was actually erected across the street from the building dedicated to his mother, Martha, but this effect was fortuitous.

14. See chap. 2, n. 15, regarding hospitals. MHC 60-22-4, August 13, August 16, and August 22, 1921.

15. MHC 58-10 and 60-22, September 2, 1921.

16. Hutchins, MHC 60-22-1, September 2, 1921; Cook, MHC 60-22-1, September 6, 1921, 59-7-3, September 7, 1921; York, MHC 59-7-3, September 8, 1921; Cook, MHC 58-14, September 8, 1921; Hutchins, MHC 60-22-1, September 9 and 19, 1921; Cook, MHC 60-22-1, September 21, 1921; Elizabeth Gaspar Brown, with William W. Blume, *Legal Education at Michigan 1859– 1959* (Ann Arbor, 1959), p. 313.

17. MHC 59-7-3, October 10, 1921.

18. MHC 60-22, September 9, 1921.

19. York, MHC 59-7-3, July 27 and September 20, 1921. Bates called the site on South University "the best in the city." MHC 58-10, September 15, 1921.

20. MHC 58-1, especially November 7–29, 1921.

21. The map of 1914 indicates the continuation of Oakland Street as Thayer; Ingalls Street is now called Tappan.

22. Bates, MHC 58-5, December 22, 1921, 58-1, December 23, 1921.

23. MHC 58-10, December 27, 1921. On December 28, York wrote to Cook urging that the project be governed by "one conception." He wrote to Bates that he and Cook had discussed the matter on the telephone and that he, York, considered it a shame that such a trivial thing as sentiment should interfere with the grand design now in mind. Cook was more decisive in his answer, indicating that he was ready to take on the issue. Surely the fraternities were not stronger than the university. The houses could be purchased immediately and leased back until building commenced. MHC 59-7-3. On January 3, Bates acknowledged Cook's firm position and that it had led the university to acquire all the land, and cordial relations followed. MHC 58-5.

24. MHC 59-18, October 11, 1922, 59-7-5, April 6 and 30, June 15 and 21, and July 19, 1923.

Patronage in Pursuit of an Ideal: The Dialectical Process in the Making of the Law Quadrangle

As the new year of 1922 opened, all was in readiness to take up questions regarding the architecture of the quad. At this point Dean Bates moved to the fore, representing Michigan's law school interests, and Hutchins stayed somewhat in the background. Hutchins remained in touch with developments and helped matters along, for example by alerting Cook periodically to the expensive work being done by Clements across the street and by smoothing the path to the regents, but he relied on Bates to communicate directly with Cook and his architects, York and Sawyer.[1] That meant communication with Edward York, in whose direct charge the project had been from its inception. Of course, Cook also communicated directly with York. At first all went relatively well as these three discussed in letters, supplemented by a few conferences in New York, the form the buildings were to take. During these years Cook said that he found the association with Bates very "workable" and noted that they had no differences in conclusions, though there was plenty of variety in their views.

Cook made it clear that he wanted something "worthwhile" and that the buildings should have "an honor character"; they should not be for "the mob" but for the choicest among the solid, reliable Michigan men. Admission should be selective and thus attract a "superior class of men," as at Oxford and Cambridge.[2] Quarters for them should be ample. Rooms should be attractive and comfortable, supporting a pattern of gracious living. The men were to have suites made up of bedrooms and sitting rooms with fireplaces where they could entertain others and discuss the legal problems under study.[3] Cook was thinking of Oxford and Cambridge and following the residential Inns of Court system. He believed that the young men should have

quiet and leisure for study, time for reflection as well as conversation with fellow students and mentors. The fine buildings would induce gentle manners and deportment as well as instill values that would elevate the profession.[4] These were, of course, all commonplace Victorian ideas, still governing the thinking of the well-to-do in the first decades of this century. Cook spelled it all out. "Surroundings count for much," he wrote, and the buildings "should be stately." He quoted Emerson's statement about luxury: "I would have a man enter his house through a hall filled with heroic and sacred sculpture," and went on to say that there was something chastening and elevating in beautiful buildings. Law schools should have them. The old idea that a law school needed only a professor and a few law books should be abandoned. A law school should be a choice spot for choice men; it should be difficult to enter and difficult to remain. Graduation should be a badge of honor and glory, a token of character and capacity for leadership.[5] Attractive, comfortable, gracious living was a part of this ideal. A baronial lounge and impressive dining hall were essential to it. Their spaces were conceived as vehicles for the free play of ideas and for the cultivation of sharp reasoning and serious thought.

Although the men would be set apart in their own quadrangle, he wanted them to benefit from contact with other realms of experience that could be brought into interaction with them there. "It will not do to make the Lawyers Club a legal monastery," he wrote. Thus he expected to have "judges in addition to students" living and dining in the quadrangle. He intended that other nonacademic members of the Lawyers Club should include practicing attorneys, who would be sometime guests, and thus representatives of both the bench and the bar should intermittently be in residence. Hence the further need for a grand dining hall, a huge and elegant lounge, modeled on a gentleman's club, and the eight comfortable guest rooms where such distinguished visitors, including leading jurists, were to be housed.[6] In these spaces the students would benefit from the presence of models in the profession, and all would mingle and exchange ideas. Standards could thus be lifted high, and the welfare of the nation would ultimately benefit.

With the model of residential academies, such as the Inns of Court, in mind, dormitories were critical to Cook's intentions. Not only were the residential units to be carriers of his ideology, they were essential to the economics of his plan. All members of the Lawyers Club were to pay dues. The funds generated from this source plus the profits from the housing fees (although the rooms were more luxurious than others on campus, they were to be rented to the law students at the going rate) were to constitute a fund that would

support legal research. Cook believed that he was thus creating a self-funding scheme that would "endow" a legal research professorship and ensure a permanent place for it. As he had shrewdly stipulated in making his gift that the university would be responsible for maintaining the buildings and providing utility services for them, this expectation of Cook's seemed cogent. This reasoning underpinned his plan from an early moment and helps explain why he wished to build such a large dormitory at the outset and why, from September, 1921, on, he had envisioned three dormitories in the quad, plus a dining hall to seat 300. The economics of his plan required it.[7]

He insisted on beginning the building program with the fee-generating residences of the Lawyers Club and, as soon as the site was decided, directed that these dormitories, the central lounge, and the dining hall dominate the quadrangle. They would establish its major perimeter and, with an impressive towered gateway linking them, would serve as frontispiece to it. York had therefore come up with the plan that is seen for these structures today (fig. 11). The stateliest of these first-phase buildings and the core of the Lawyers Club was to be the large lounge (fig. 12). It was to command the axial corner, at the intersection of South University and State Streets. The next dormitories to be built would then extend along Tappan Street and follow along to the Tappan-Monroe corner, leaving the rest of the land for the other buildings.[8] In the early drawings for the project, the first group of buildings was sketched in as just described, while the others were indicated very tentatively in broken outline (fig. 13).

The other requirements for the ensemble were a library and a law building. From the beginning the library had been uppermost in Bates's mind. As the disposition of buildings within the quadrangle was being determined, Bates urged that the law building and its library be in the center of the quad with a range of dormitories circumscribing it and buffering it from the streets beyond. Above all the library must be quiet, Bates said, and he had already pointed out that trolley cars ran along State Street and made a noisy turn onto Monroe (fig. 8), at the exact corner where Hutchins Hall is now.[9] However, York persuaded Cook that the library should not be in the center but at the back of the properties, on axis with the final range of proposed dormitories along Monroe Street, and that it should have lower dormitory buildings about it on either side. This would have been reminiscent of medieval monastic planning, where dorter, cellar, and refectory are so annexed about one side of an imposing church that they form a courtyard on that side. Such planning was inevitably still vestigial in the architectural tradition York inherited, and it appealed to Cook as well.[10] It was a scheme seen in countless

abbeys, since the time of the St. Gall plan, and in the English collegiate quadrangles that developed from them. With the library at the back of the plot, the courtyard could be like a cloistered garth in its effect.

In a modern survey plan (fig. 14), it is evident that the courtyard is not a true square and that the quadrangle is thus something of an illusion. It does not claim as much and as central a portion of the ten-acre plot as it seems when one is within it because of the particular siting of the library and its stack building. Cook was intent on having a large reading room for the library. He wanted its facade to be imposing from the courtyard side, and he wished it to be easily accessible from there. He was less concerned about practical requirements such as library stacks. Bates was very concerned about the stacks, both about their location in the overall plan and their adequacy. He was of course joined by Hobart Coffey in these concerns. Bates suggested that the most feasible design would be to have the stacks extend northward, projecting from the library building into the courtyard. That would have been an aesthetically ill-advised move that would have made the stacks the central, focal feature of the entire ensemble. It would have cost the integrity of the courtyard and would have seriously compromised the overall quadrangular conception of the plan. York's accommodating solution was to move the entire library building forward into the court from Monroe Street and then project the stack building southward, ensuring the relative closure of the quadrangular court.

The claustral effect of the court with its broad stretches of lawn (fig. 15) is interestingly in harmony with the greenswards about the outer perimeter of the ensemble. Early in the project, Cook had asked that the buildings be set well back from the street (fig. 16). He explained that he wanted ample greenswards about them on the street side (fig. 17), and he repeatedly referred to the need for "wide grass margins on the edges of the plot."[11] He kept fussing with York over the actual amount of lawn and firmly asked for specific dimensions, which he worked out on his measured plans at home to verify the sufficiency of these gracious spaces. In the setbacks there were to be attractive but low plantings. In combination with the relatively restrained height of the buildings, this scheme had a felicitous consequence. Cook had insisted that the residential units be no more than two to three stories, to look domestic rather than institutional. The open balustrade devised by the York and Sawyer shop to screen the upper storey on the South University side lightens it and creates a baronial illusion while it plays down any suggestion of an attic garret, which Cook wanted to avoid, especially on that facade. The later dorm on Tappan Street, the John P. Cook Building, has an addi-

tional storey and thereby loses some of the charm of the earlier facade. To test the efficacy of these efforts, one can simply observe the greater number of stories at Martha Cook and its lack of lawn as it abuts Tappan Street. Such features give it a decidedly more institutional look in contrast to the image sought for the quad. Also relevant are the consequences of budget cuts Cook made as he reviewed early estimates of costs. He checked them carefully and marked numerous items for omission. These cuts represent interesting judgments. He did not cut anything from the staggeringly expensive Dining Hall, but he did scratch early on the amenity of a wrought-iron gate, intended for the main passage into the courtyard through the towered entrance on South University. Had its execution been allowed, it would have been done by the famous iron master Samuel Yellin of Philadelphia, who did wrought iron work at Bryn Mawr, Yale, and other ivy league campuses.[12] It would have made the Ann Arbor archway resemble more closely the Memorial Gateway on High Street at Yale (fig. 18), completed by Yellin just at this time. The omission of such an iron barrier had a happy effect, however. Without it, the main archway of the street facade offers an open, welcoming entrance passage into the courtyard (fig. 19 and see figs. 65–66). The resulting implications, when coupled with the other points stressed by Cook with regard to the greenswards, are substantial. The deep setbacks, ample lawns, careful plantings, and relatively low roof lines, conjure up an image of gracious manor houses and an accessible, penetrable quadrangle.

The viability of this argument can be tested by considering the contrasting effect of the scheme followed at the University of Chicago. In Henry Ives Cobb's plan (fig. 20), the buildings cling to the curb in a long, unbroken file, suggesting an intimidating impenetrability.[13] At Yale, James Gamble Rogers, architect of the Harkness quadrangle buildings, also used the land "thriftily." He intentionally walled and moated the dormitories for security purposes, to "keep out the sneak-thieves" and "marauders," as he put it.[14] The moats (fig. 21) were intended to have a depth of about four feet, and the walls edging them were to range from about three to six feet in height. They successfully thwart intruders. In their look, they also suggest that all nonresidents are excluded, a very different expression than that conjured up by the architecture in Ann Arbor. Of course, Ann Arbor, with its relatively nonurban environment, could better afford the welcoming look of these setbacks and open passageways, whereas locked gates and fences were perforce more requisite on the New Haven campus. Still, these are expressive forms that send clear messages to observers about exclusion and non-access. Without perhaps realizing it, and simply following his instinct for the things he liked,

such as an imposing mass managed with the greatest possible economy, Cook helped York reach for an expression of stately accessibility. The result reflects surprisingly well the character of its location. Such open and friendly gestures are still very characteristic of Ann Arbor.

This expression is also created in part by the warm color, rough-hewn texture, and simple massiveness of the ensemble's raw material, its stone. The stone was awesome to those who first saw the carloads of it being unpacked at the corner of South University and State Street (fig. 22). As it went up, its loveliness was repeatedly commented on, by Hutchins, President Burton, the regents, and many others. Even Bates was lyrical when he actually beheld it. It was more beautiful than anything he had expected.[15] It is a major contributor to the aesthetic effectiveness of the architecture. Again, Cook's decision accounted for it, though this was the result of a series of interactions with York and with Bates and was determined to an extent by his desire for economical grandeur. In the earliest discussions, he had specified that the buildings must be of limestone. Stone had greater permanence and nobility than brick, and he had simply presumed that the entire complex would be of limestone. That was the case for much Oxbridgian work. Limestone was also the principal material for the University of Chicago quadrangles, still underway at this time. These were, of course, mostly underwritten by Rockefeller money. When the early estimates for the Ann Arbor quad came in, Cook was shocked by the cost of limestone. In Eidlitz's 1919 budget, masonry would have made up almost a third of the total expense, and that was true again later in 1922.[16] Cook asked York what savings there would be if he should consider dropping back to brick and stone in combination, the scheme he had used at Martha Cook. Red brick would have created a very different look, like that of a number of Albert Kahn buildings on campus. Most of these were constructed during the "red brick" phase of the university's architectural history, represented by Hill Auditorium, 1913, and Natural Science, 1914. In an effort to be helpful with the cost issue, Bates wrote to York that *he* would be quite satisfied with brick. It would allow a big saving. Or stone could be procured locally, "from this part of the country," such as the gray stone from Kelley's Island. "However," Bates said, "I would prefer brick."[17] This brought a retort from York, who complained of the trouble these remarks had cost him with Cook ("your suggestion of brick has not made it easier"). Cook sourly retorted that Bates's suggestion was a cheapening of the project (even though he had himself considered it earlier).[18] Thus was firmed up Cook's interest in stone. At this point, in late

October, 1922, York became emphatic. He wrote Cook that the "design [of the work] calls for stone" and that he hoped that Cook would not even consider brick.

York then became instructive about the quality of stone. He explained various granite, limestone, and sandstone types and sent Cook samples of the three kinds of stone used in the Harkness buildings at Yale (including Briar Hill sandstone from Ohio and seam-face granite from the vicinity of Plymouth, Massachusetts). Cook thought the color of some of the Yale stone, a rusty-red granite, flamboyant.[19] York explained the advantages of seam-face granite. It has a great variety of color, it can be muted in tone, and it has variations that add interest, especially with broad expanses of field.[20] Discussion continued during the fall of 1922. York visited the granite quarries near Plymouth and Cook located an example of the granite near his home in Manhattan. It had been used in a building right across Seventy-first Street, another fortuitous happenstance.[21] Cook took a liking to the seam-face granite that was quarried at Weymouth.[22] From some formations within the beds, it has a warm ochre color, varying from burnt orange to a creamy gray with the seam providing extra visual interest. In addition to being fine-grained and durable, it is readily quarried. It splits naturally into sheets and requires little additional dressing. New quarries had opened at Quincy and Weymouth, and, by happy chance, it was also the cheapest. Its use would allow a substantial saving. By early May, 1923, the granite was selected.[23] Indiana limestone could thus be limited to the ornamental portions of the buildings, to the quoins, the trim, door frames, window casings, and the like. Colonel Starrett of the Starrett engineering firm, the contractor for the first building phase, and York went together to the Bedford quarries to make selections from the Indiana limestone beds. By August, 1923, there were ten carloads of limestone from Indiana and fifteen carloads of granite from Massachusetts on the site in Ann Arbor. Photos illustrating progress with construction were dispatched regularly to Cook and show these shipments in readiness (figs. 22–25).[24]

Although York emphasized that seam-face granite had been used at Yale for parts of the Harkness quadrangles, he made no effort at Michigan comparable to that of Rogers at Yale to heighten the picturesque effect by occasionally mixing in courses of different types of stone or brick, or by artificial weathering of the material, or by attempting optical refinements as at Yale (where darker stone is used in lower courses and lighter above, especially in the Harkness Tower), though the effects of broken color are similar.[25] The

blocks of seam-face granite used in Ann Arbor were to retain their rough hewn surfaces, creating a rusticated effect. This pleasing quality of variegation and texture gives unity and harmony to the work. As Cook was adamant that there be no "gew-gaws" and "gargoyles," there is relatively little sculptural ornamentation and no statuary at all to dissipate its simple effectiveness.[26] Again, economy is a virtue. The austerely rich result reflects Cook's taste, one that meshed well with that of York's partner, Philip Sawyer, whose liking for heavy masonry styles had become a feature of York and Sawyer work. Sawyer had early training as a geological engineer. Among his papers and memorabilia survive some personal early snapshots showing particularly interesting rusticated stonework that seems to have impressed him.[27] Under his influence, the firm became famous for its fine handling of rustication, a feature that had just been perfected in the York and Sawyer design for the Federal Reserve Bank in Manhattan.[28] As a result of this combination of factors, the Michigan stonework is distinctive (fig. 26). It is unusual in being warm in color (unlike the predominantly cool gray tones of the stone of Princeton and Bryn Mawr), chaste in finish (unlike the heavily sculpted and ornamented Harkness quads at Yale), yet interesting in texture (unlike the monochrome, unbroken smoothness of the limestone at Chicago). It is a fortunate blend of Cook, York, and Sawyer.

The style of the buildings was to be "Gothic." Although Bates liked Gothic style perfectly well, he considered function more important than beauty and feared that Gothic buildings might be dark. He wrote to that effect in January, 1922. York responded with a rationale: "The reason we have adopted the Gothic style of architecture is because it allows lots more window area, without sacrificing the architecture. There is no reason why your building should not be well lighted. We have a general feeling here that it makes no difference how beautiful a building may be, if it is not well adapted for its use, it is a failure."[29]

As for Cook, with regard to aesthetic decisions, he was admittedly not knowledgeable about art, but he was nevertheless intrepid in his engagement with York as an artist-patron dialectic developed. From the beginning, despite having only vague conceptions of period styles of architecture, he had expected the quadrangle to be basically "Gothic." He had told Bates as soon as the site was determined that it would be helpful if he would "run over to England to study their buildings."[30] It seems to have been clear to him that his buildings should evoke English forebears, particularly the English Gothic of Oxford and Cambridge, and that the residential units of his plan should suggest Elizabethan manorial forms. Tudor and Jacobean elements seem to

have appealed. These were the general features underlying grand buildings of the 1910s and 1920s and had become a kind of koiné for them. A wave of English Gothic forms had penetrated the style known as Collegiate Gothic architecture, and it had deluged academic campuses during this period, particularly owing to the influence of Ralph Adams Cram.[31] Although Cook made little attempt to master the intricacies of these historical styles, he liked them in general. He seems simply to have followed his instinct about them. He sometimes expressed himself inconsistently (the library should look like a library or a chapel at Oxford or Cambridge, but it should not look like a cathedral; it should not be too tall, but then it should look much taller; and so on), but he was specific when he made requests for changes to the designs York presented him. For example, he asked York to enlarge the windows of the Dining Hall of the Lawyers Club, making them much wider, and he asked that York enlarge considerably the windows of the Legal Research Building's reading room.[32]

The dialogue between York and Cook about such matters can sometimes be closely followed. Considering York as the artist and Cook as the patron, we can trace their exchanges and gain insight into the impact of the artist-patron dialectic on the creative process. The shaping of the Legal Research Building or library (fig. 27), with regard to its roof lines, towers, and ultimate silhouette, will serve as a case in point. Cook wrote York that they might look over the designs together, "you furnishing the art and I the philosophy."[33] In April, 1928, York took to Cook's home preliminary drawings for the proposed library, and Cook pondered them. He then wrote to York that the attractiveness of his design was not up to that of the Lawyers Club and looked "stubby" in appearance. Cook said, "Why not add minarets at the four corners or better still four towers similar to the towers midway in the Lawyers Club Building? I am not an architect or artist but the proposed building does not look right to me and I don't like it. I don't wish to insist on anything but you have the genius to make that building equal to the Lawyers Club and I am trying to awaken that genius. It looks like a *sarcophagus* Try again on those corners. American art is at stake and immortality awaits you." Then, in a postscript, he added, "Why not put tops on the four corners similar to the tops on the Dining Hall . . . ?"[34] By "tops" he must have meant the small Tudor domes crowning the towers of the main arched entranceway on South University. Six days later Cook asked for a new sketch with the turrets he had suggested and also asked to have the lower windows widened out.[35] The next day he asked whether the library could be improved by "raising the corners fifteen to twenty feet," and he suggested that perhaps

York might put the square towers ("square tops") "up higher in the air" to relieve "the cut-off appearance of the present ends of the building."[36] Three days later he was even firmer, saying, "The Legal Research building will be the central building but I think that is the very reason why it should not present a stubby appearance. . . . kindly raise the corners twenty or thirty or forty feet [!] and let us see how the whole building will then look."[37] Of course the sheer size of the library was already overwhelming the space of the court. York responded that he had worked out sketches for these suggestions but thought that Cook would find that raising the towers twenty feet made them look "pretty high."[38] Finally, Cook sent York an issue of *Country Life* with a picture of a familiar library at Oxford that had a silhouette he liked.[39] York escaped briefly to jury duty, but the discussion went on into the fall, with Cook hammering away about the sawed-off, stubby look of the building. In November he continued to press York about the four towers and now suggested pinnacles for them, such as had been used for the Lawyers Club.[40] On November 30, York explained to Cook his ideas about the massing of the towers in relation to the window area of the library. He also explained his desire to give the exterior greater stability and to have "good proportions" for the large reading room and his reluctance to overdo it. However, Cook continued about the pinnacles, and York made further revisions. Following a rapid series of exchanges about the pinnacles during the next few weeks, in which Cook praised improvements but still considered the building to look squat, he wrote on December 5 that as a layman he did not know much about architecture and yet had a fairly reasonable idea of how things look. He thought a little sparkle and fancy would do no harm to the ponderous building. York answered that he was revising but that the solidity of the mass as worked out was both characteristic of the style and attractive and that there would be "sparkle" in the ornament of the towers themselves. On the thirteenth of December Cook still thought the pinnacles could be improved and urged York on, saying, "let loose your genius; put a little more life into the picture. Make it as attractive as the Lawyers Club Building. You can do it." York responded on the eighteenth. He explained to Cook that though he was making the pinnacles more prominent, the library would have to be considered a little differently than the other buildings as it was for a different purpose. He considered it the heart of the group, that it would be as beautiful as the buildings already constructed, and that it would indeed be, "without any doubt, the best looking of all. We have every intention that it should be!" Cook finally seemed satisfied. He then wrote that he considered the work first rate (December 20 and December 26). He now felt ready to send the

sketches to the regents for their approval and asked York to prepare to go to Ann Arbor to present the drawings at the regents' January meeting. These were the last of Cook's letters that York could actually have read, however, as York was suddenly taken very ill. He died in the hospital a few days later on December 30, 1928.[41]

There was a surprisingly seamless transition at the York and Sawyer firm as Philip Sawyer immediately took over Cook's project. He traveled to Ann Arbor and presented the materials to the regents, who resolved to accept the proposal on January 11, 1929.[42] In February Sawyer suggested to Cook that elevating the entire library, by using a higher foundation or terrace, might give it the importance Cook sought. Cook agreed. Thus was finally put to rest the question of the towers.[43] The question had been primarily a problem of scale. The fact that it had so vexed Cook was surely in part due to his absence from Ann Arbor and in part caused by the vagueness of the image he must have had in his mind's eye. It must have been difficult for him to visualize the relationship between the very large size of the structure that was required for the needs of the library and the smaller size of the other buildings of the quadrangle and thus to resolve the dilemmas of scale and context. Forming his impressions on the basis of individual drawings and photographs, rather than a site visit, would have made it hard to assess the overpowering character of a building such as he wished within the strictly contained plot. In addition, Cook's guiding image—perhaps what he called his "philosophy"—was vague. His conception of an architectural masterpiece was ambiguous. He was not particularly religious. He had been raised in Hillsdale to a high moral and ethical standard but without special emphasis on churchgoing. He seems to have reflected regional thinking in being reluctant to have his educational buildings look like churches. Yet there was inconsistency in this, for while he said that he wished a library, "not a cathedral," the enormity and height he requested were cathedral-like, and the wide, stained-glass windows, as well as the towers, turrets, and pinnacles he insisted on, were, of course, the very stuff of cathedral design. Whether he was aware of it or not, these features of medieval religious art constituted much of what had filtered down from the perpendicular and decorated styles of English cloisters and cathedrals to the architecture of English collegiate quadrangles, such as that of King's College, Cambridge. They had become a secularized visual rhetoric that deeply influenced Cook's taste.

York gracefully acceded to Cook's requests as he had on many occasions during the preceding years. As patron Cook exerted pressure that was a constant and often an ameliorating force, making the relationship both crea-

tive and productive. York was the true philosopher.[44] He took Cook's prodding easily in stride. He had realized from the beginning that there would be such debates when he said he expected the firm would have some fun with the project. The closest the dialectic came to being an altercation was during the first building campaign. It turned on the theme of the sculpture prepared for the central towered gateway, but even then York was able to joke and shrug, while for Bates it was more serious. This subject will be dealt with in the next chapter.

NOTES

1. "Bates consults with me constantly . . . he will be the action man " MHC 60-22, January 21, March 20, and January 27, 1922.

2. MHC 60-22, March 17, 1922, and October 21, 1921; UMLSA, July 31, 1923; MHC 59-1, January 13, 1925.

3. Bates and Cook were regularly at odds over judgments regarding the luxuriousness of the furnishings. They hammered out matters of the size of the bedrooms, the number of singles and doubles, multiple entries versus corridors, and the fittings of the rooms. Bates preferred Spartan furniture and considered such amenities as sitting rooms with fireplaces and upholstered arm chairs, MHC 58-8, December 6, 1922, needlessly indulgent, indeed even damaging, causing "bad effect" at Martha Cook, MHC 58-1, July 19, 1922. There were also differences regarding the possible inclusion of "lit" students, which will not be taken up here. MHC Burton Papers, 14-8.

4. MHC 60-22, October 21, 1921.

5. MHC 59-1, April 23, 1930, 60-22, October 21 and 31, 1921.

6. UMLSA, August 14, 1923.

7. He expected profits in excess of $30,000 per year, but this proved to be overly optimistic and quite unrealistic. MHC 58-13, October 17, 1923.

8. Tappan Street was formerly named Ingalls (figs. 8–9, 13). The second dormitory constructed, the John P. Cook Building, extends along Tappan opposite Martha Cook. The third, to have been located at the corner of Tappan and Monroe Streets— the major opening off the quad today—was to have been the "Cooley dorm." It would have been named for Cook's teacher Judge Thomas McIntyre Cooley, but it was never built. Cook had at one time considered extending the dormitory ranges along State Street; he then shifted to Tappan, leaving State Street for the location of the law building.

9. MHC 58-5, December 24, 1921, January 12, 1922, and December 22, 1921.

10. "York satisfied me at once that this was the proper plan in view of the height of the law building to contain the law library and the stacks." MHC 58-10, March 9, 1922.

11. MHC 60-7, October 21, 1921. The landscaping and planting was entrusted to J. C. Van Heiningen of South Wilton, Connecticut, whose plans were monitored closely by Cook. MHC 59-12, September 1924 and June, 1925. William Pitkin of Pitkin and Mott, Cleveland, handled the later work. MHC 60, July, 1932.

12. He was later commissioned to do work at Hutchins Hall, including its commemorative tablet. As Cook trimmed away amenities to bring costs under control in 1922 and scratched the "ornamental gate," he thereby saved $6,000. The fountain outside the Dining Hall also fell away in the early budget review. Specifications, MHC, 59, p. 5.

13. Jean F. Block, *The Uses of Gothic: Planning and Building the Campus of the University of Chicago, 1892–1932* (Chicago, 1983), p. 12.

14. James Gamble Rogers, "The Harkness Memorial Quadrangle, Yale University, The Architectural Plan," *Architecture* 44 (October, 1921): 288; idem, "The Memorial Quadrangle and the Harkness Tower at Yale," *American Architect: The Architectural Review* 120, no. 2379 (October, 1921): 299–314. These buildings date from 1917–21.

15. MHC Burton Papers, Law School, 60-7, January 27, 1924; and Bates, 58-13, October 4, 1923 (re: the richness of the texture and the depth of color of the stone), March 24, 1924 (the "transcendent beauty of the buildings").

16. Ca. $300,000 of ca. $1,000,000, MHC 59-7, March 6, 1919, and again in 1922.

17. MHC 58-5, September 30 and October 4, 1922.

18. MHC 58-5, October 21, 1922.

19. MHC 59-18, October 13 and 20, 1922, 59-7-4, October 25, 1922.

20. MHC 59-7-4, October 27, 1922.

21. MHC 59-7-5, April 30, 1923.

22. Plymouth Quarries, Inc., East Weymouth, Massachusetts, MHC 60-1, April 11, 1922, 60-2, August 19, 1929, p. 56, 60-8, September 19, 1929. David B. Emerson, "Stone," *Architecture* 51 (June, 1925): 231–32.

23. MHC Burton Papers, April 25 and May 4, 1923.

24. MHC Law School, 64.

25. Rogers saw an analogue in this to Impressionist painting. Rogers, "The Harkness Memorial Quadrangle," 297, 301–2; idem, "The Memorial Quadrangle," 311.

26. See chap. 5 for fuller discussion of this point.

27. Avery Architectural and Fine Arts Library, Columbia University, Drawings and Archives, Philip Sawyer Collection (AA). Particular thanks are owing to Janet Parks for her assistance with the use of these collections.

28. M. Shapiro, *The Dover Walking Guide, New York* (Toronto and London, 1982), pp. 40–41; *American Architect* 116 (November 5, 1919): 569–80.

29. MHC 58-5, January 7 and 9, 1922.

30. MHC 58-10, September 21, 1921.

31. Alexander Jackson Davis, who devised schemes that were never implemented for the University of Michigan in the mid-nineteenth century (including a chapel modeled on the one at King's College, Cambridge), first used the term Collegiate Gothic (see chap. 1, n. 3); Paul Venable Turner, *Campus, An American Planning Tradition* (Cambridge, Mass., 1984), p. 124; Ralph Adams Cram, *The Gothic Quest* (New York, 1918); idem, *My Life in Architecture* (Boston, 1936); Douglass Shand Tucci, *Ralph Adams Cram, American Medievalist* (Boston, 1975); Montgomery Schuyler, "Cram, Goodhue and Ferguson: A Record of the Firm, Representative Structures, 1892–1910," *Architectural Record* 29 (January, 1911): 1–112; idem, "Architecture of American Colleges, II, Yale, III, Princeton, V, University of Pennsylvania, Bryn Mawr," *Architectural*

Record 26–28 (1909–1912); Peter Fergusson, "Medieval Architectural Scholarship in America, 1900–1940: Ralph Adams Cram and Kenneth John Conant," *The Architectural Historian in America, Studies in the History of Art,* vol. 35 (Center for Advanced Study in the Visual Arts, Symposium Papers 19, Washington, D.C., 1990), pp. 127–42. With Charles Collens, the style extended to museum buildings. Mary Rebecca Leuchak, "The Old for the New: Developing the Design for the Cloisters," *Metropolitan Museum Journal* 23 (1988): 257–77; William H. Forsyth, "Five Crucial People in the Building of the Cloisters," *The Cloisters: Studies in Honor of the Fiftieth Anniversary* (New York, 1992), pp. 51–62.

32. This measure allowed more light, and it saved on stone. MHC 58-5, October 21, 1922, 59-7-11, March 13 and 30 and April 17, 1928.

33. MHC 59-7-11, June 27, 1928.

34. MHC 59-7-11, April 10, 1928.

35. MHC 59-7-11, April 16, 1928.

36. MHC 59-7-11, April 17, 1928.

37. MHC 59-7-11, April 20, 1928.

38. MHC 59-7-11 and 59-8, April 26 and May 1 and 3, 1928.

39. MHC 59-7-11 and 59-8, May 31 and June 6, 1928.

40. MHC 59-7-14 and 59-8, November 9, 1928; see also November 16 and 21, 1928.

41. MHC 59-7-14 and 59-8, November 30, December 4, 5, 6, 8, 11, 12, 13, 18, 20, and 26, 1928.

42. MHC 59-7-15 and 59-8.

43. MHC 59-7-11 and 59-8, January 14, and February 15, 1929, 59-4, March 19, 1929.

44. Philip Sawyer, *Edward Palmer York, Personal Reminiscences by His Friend and Partner, Philip Sawyer, and a Biographical Sketch by Royal Cortissoz* (Stonington, Conn., 1951). Informal, dramatized references to York (as in the party skits enjoyed by the firm on festive occasions) that are preserved among Sawyer's memorabilia also throw light on York's interesting character. AA. See also: *Office of York and Sawyer Architects: A Brief History and a List of its Work* (New York, 1948).

Modern Uses of Mediaevalia: *Thematic Programs in the Quadrangle*

There are no freestanding sculptures in the quadrangle and no statues of figures incorporated into the architecture of the Law Quad ensemble, even though these were quite usual additions to monumental buildings of the period, especially on university campuses. Cook really did not care for them, and he was shocked at their cost. He had learned during the first phase of the project that models must be prepared and that these were very expensive. He wrote to York after the completion of this phase in August, 1925, that with regard to future projects, "I shall ask that ornamental work be submitted to me before I approve the plans." A week later, as he moved toward the second phase of his building program, he wrote that he would not care to have "such absolutely superfluous things, as those gargoyles with miniature carved heads. They run into money and are of doubtful taste. I class them with lions rampant and Laocoöns—all very fine but out of place and out of pocket." In 1929, following York's death, Cook wrote to York's partner and successor as chief architect of the project, Philip Sawyer, that he should beware of costs. "I used to remind York to kindly bear in mind that I am not exactly the Bank of England and I must say that he occasionally would put on the brakes. I have the greatest respect and admiration for the visions you see and the dreams you dream but remember that a bank account has no illusions. And no gargoyles, lions rampant and such like gewgaws. Bad taste and useless expense."[1] Such sculptures were commonly executed elsewhere. In addition to abundant use of small-scale sculpture, Princeton buildings have numerous full-size statues, representing dignitaries, such as former Princeton presidents (e.g., John Witherspoon and James McCosh) that add a thematic dimension to their architecture. Yale's Harkness Tower alone has

eight portrait statues, of Elihu Yale, Jonathan Edwards, Samuel F. B. Morse, and others, in addition to twelve symbolic figures (among them War, Peace, Courage, and Freedom) and full-size figures representing the wars of our country, including one of a World War I soldier with a trench helmet and rifle.[2]

In the early years of the Michigan project, however, Cook did not seem as yet to have an aversion to small-scale architectural sculpture, particularly that which might be classed as decorative ornament, and he seemed to like stained-glass windows. In fact, in the early 1920s, during the first building phase, he asked York to make the exterior of the Dining Hall more interesting by widening the windows and enhancing the ornamentation. He had feared it too plain. He was pleased with the results and asked that more "sparkle" and "fancy" be injected into the design of the later Legal Research Building.[3] He liked the idea of carving the beam ends of the trusses of the Dining Hall ceiling with images of famous jurists, and he enjoyed determining who the members of this special "hall of fame" might be, though he was again appalled at the cost of the carving and in the end cut back on the number of jurists to be so honored. While he declined to involve himself deeply with the programs for the various stained-glass windows, he appeared to approve of them in general. Thus, though there are no full-size statues, there are a number of cycles of figural imagery presented in stone corbels and reliefs as well as in stained glass that add thematic interest to the Michigan buildings. Most of these have programmatic coherence, as is particularly evident in the Legal Research Building, whose windows show the arms or seals of the universities of the world on the interior, and whose towers display a series of carved shields with the seals of the forty-eight states of the union on the exterior. The cycles of figural motifs for the Dining Hall windows also present interesting iconographic programs.

Stained-Glass Windows

The Lawyers Club Dining Hall

The Dining Hall at Michigan (1923–24, frontispiece, fig. 28), follows its late-medieval model, King's College Chapel at Cambridge (1448–1515, see fig. 90), in having tall lancet windows filled with stained glass, but it departs from its Cambridge ancestor with regard to subject matter. The chapel windows have religious imagery, arranged in a program of Old and New Testament typologies. In the Michigan windows, the iconographic objective appears

secular. Still, its reliance on conventional symbols arranged in cyclical form endows it with some reminiscences of religious programs. The vertical tracery of the lancet windows provides an excellent framework for ranges of imagery; thus the upper lancets contain the twelve signs of the zodiac, corresponding, roughly, to the twelve months of the year. Six of them are in the upper east windows enframing the seal of the state of Michigan, and the other six are in the west window on either side of the seal of the university. The original cartoons survive (figs. 29–31, Appendix B) and clearly illustrate such signs as Cancer, Libra, Scorpio, and Leo and the design for the program as a whole.[4] Observed from the interior, the signs are arranged according to the calendar, reading from right to left across the upper east window, from Pisces and Aquarius to Libra, or January to June, and again from right to left across the upper west window, from Virgo to Aries, from July to December. During the Middle Ages, such cycles would be commonplace. From the twelfth century on, the zodiacal signs were usual themes for abbey and cathedral facades, where they would suggest the dimension of time and the perpetual renewal of the year within the implicitly eternal Christian universe. Cycles at Vézelay, Autun, Saint-Denis, Chartres, and Amiens are particularly famous examples in stone, and there are many later instances in other media as well. The zodiacal signs are usually coupled in medieval iconography, however, with parallel cycles illustrating the labors or activities of the months. Although references to seasonal activities do appear elsewhere in the Michigan quadrangle program, in the stone corbels to be discussed below, they are replaced here in the windows by a collection of symbols, representing justice, knowledge, time, prosperity, wisdom, commerce, fortune, peace, and hope, intermixed with the seals of the university, the state, and the nation. These medallions are arranged in the lower range of the windows. Featured in their centers are the ship of state medallion on the east and the University of Michigan seal on the west. Although the scheme is thus vestigial and partial in relation to its medieval forebears, and although such fragmentary paraphrasing of the past is typical of the way in which Neo-Gothic or Collegiate Gothic styles borrow from their medieval models, the program as a whole with its extramedieval additions expresses interestingly, even if only in an attenuated way, the ideal of Cook—to make the University of Michigan central in its relation to the state and the nation and to elevate it within a lofty, temporal and socioethical context. The program makes the university part of recurrent and therefore eternal time as it symbolically touts Michigan's ennobling values. The emphasis on coupling the university and the state is also present at Yale.[5] This idea is reinforced in the stone carvings flanking the entrance to

to suggest to put in the remaining four of the nine spaces. Angels, saints, etc. would certainly not be appropriate, nor emblems of industry. Anything pertaining to the wilderness, such as Michigan was when my father went there, would be all right but I don't know that there are such. You might inquire." Sawyer responded on January 29: "We will just have to do our best with the designs."[11]

In February Sawyer went to England on the second trip he made there after taking over the Cook project. His intention was to study more intensively the English buildings to be evoked by the structures in Ann Arbor. On his return in March he was enthusiastic about Oxford in particular. By May he had completed the designs for the John P. Cook Memorial Room windows. His letter of May 12, 1930, spells out some details he would add to improve the central panel, and he notes that while in England he had studied the old windows at Oxford and had spent a number of afternoons in South Kensington, which had rewarded him with a "better idea of how to design glass than ever before."[12] The Memorial Room windows thus contain medallions that have stylized wreaths inscribed within them. These in turn circumscribe symbols of eight branches of the law (Appendix B): religious (sacred books), moral (tables of the law), ceremonial (burning altar), natural (helmet and shield), common (wig, gown, and gavel), international (flags and fasces), civil (sword and balance), and statute (scroll and sceptre) law. Michigan emphasis within these is assured by the central medallion with its particularly brilliant coat of arms and the inscription about it, "John P. Cook 1812–1884."

The Legal Research Building

During these early months of 1930, following Hutchins's death in January, Sawyer was also working on the designs for the large windows of the Legal Research Building's reading room (1929–31, figs. 27, 32–33). He was enthusiastic about the coats of arms he had seen in windows while in England and asked Cook whether he would be amenable to using a similar plan for Ann Arbor: "I would like to ask whether it is agreeable to you to have us use in the lower windows, which are most conspicuous, the coats of arms of the American colleges and in the upper windows, which are furthest removed from the eye, the insignia of the English colleges at Cambridge and Oxford. I hope you will agree because I think these will be very decorative and in looking at them again in February it seemed to me that there is nothing more attractive in Oxford than the coats of arms in some of the old windows." In

the same letter he noted the effectiveness of such "spots of color" as used by York in the Dining Hall during the early phase of the project.[13] Cook agreed to the idea of using the insignia of American and English colleges on May 14, and later in the month, on May 23, Sawyer indicated progress with the construction of the Legal Research Building; the stonework was complete to the second floor, the stacks to the third.[14] Cook's death came little more than a week later, on June 4, 1930. To the end Cook seems to have been more interested in the impact of words than images as conveyors of his thought, for his attention in his writing during these last weeks was devoted to the wording of the inscriptions for this library building. His last letter about them was written to Sawyer on May twenty-second. In it he spelled out the inscriptions he would like carved at the entrance to the building, including the maxim that can be read as one exits from the library reading room: A LITTLE LEARNING IS A DANGEROUS THING. DRINK DEEP OR TASTE NOT.[15]

The actual making of the glass was turned over to Heinigke and Smith, stained-glass makers on East Thirteenth Street in New York. Otto W. Heinigke, head of the firm, wrote a letter to Sawyer in which he described gathering the arms and seals of colleges around the world, including those in India, China, and Australia. He noted that only two of the more than two hundred responses he received were in a language other than English. He also described the making of the cartoons, the twenty or thirty types of designs represented, and the scheme for the distribution of the arms. A copy of the chart presented by him to the library at the conclusion of the firm's work in 1930 is still on display in the building (fig. 32).[16]

The window scheme devised by Sawyer and Heinigke for the library does not so much emulate English windows as appropriate the prestige of English universities into its plan. Above the study tables the arms in the clerestory's medallions refer viewers to Paris, Rome, Madrid, Berlin, Nanking, and so on.[17] Their program effectively carries Michigan into a global orbit, making the university what we would call today world class. The distribution of the arms pointedly relates Michigan to a subset of this huge world context by repeatedly coupling it with Oxford and Cambridge. The great perpendicular windows of the east and west walls of the library are visually most prominent and thematically most important (fig. 33). There the Michigan seal occupies the larger, taller, central lancets and Michigan is symbolically shown with its peers. In the upper range on the west the Michigan seal is set in the center and flanked by those of six Cambridge colleges (Trinity, Corpus Christi, Kings, Pembroke, and so on). In the lower range are mem-

bers of Big Ten universities. In the more privileged eastern window, Michigan is again centered and flanked, this time by six Oxford colleges above (Jesus, Christ Church, Queens, Oriel, Brasenose, Balliol) and by American ivy league colleges below, Princeton and Yale being appropriately placed on the right and left (fig. 32), followed by Columbia and Harvard. In studying the chart for the entire reading room, with its more than one hundred and thirty-one windows, it is evident that in addition to those just cited, there are two more full windows given to Cambridge near the west end (nos. 127 and 128) and three to Oxford (nos. 117, 118, 119). At the east end, near window 110, another adjacent window is given over to Cambridge college arms (no. 114) and two more still to Oxford (nos. 105 and 106). This adds up to a total of eighteen lancets or most of four entire clerestories for Cambridge and twenty-six lancets or most of six clerestories for Oxford, with Michigan as the nexus of it all.

This exercise in self-aggrandizement was not first invented by Sawyer for Michigan as his letter suggests. An earlier scheme can be seen in the University of Chicago's Harper Memorial Library, of about 1912, where the arms and shields of the colleges of the world are selectively positioned about Chicago's own. Michigan is graciously presented there.[18] Both programs contrast with Yale's, wherein Rogers's cathedral-like Sterling Law Library (1930–31), smaller but very similar to the Michigan library in form, the windows present scenic vignettes.

Hutchins Hall

After Cook's death in 1930, things took a decidedly different turn. The new John P. Cook Dormitory and the Legal Research Building were nearing completion and plans for the large "law building" that was to be the teaching and administrative center of the complex, which Cook had held off to the end— much to the consternation of the entire Michigan contingent—could finally make speedier headway. Cook had already determined that this building should be named for Hutchins (figs. 34–35), yet many decisions about it were still to be made.[19] A faculty committee was formed and chaired by E. Blythe Stason. The committee fielded complaints such as those about the use of English cathedral glass in the faculty offices. The professors feared distorted views as they gazed through their windows, and they eventually insisted that hundreds of the antique glass panes be removed and plain glass installed in their place.[20] There were additional subcommittees. For example, an in-

scription committee deliberated over the epigrams for the entrance to the galleries of Hutchins Hall from January until July of 1932, when the phrases were finally chosen (Appendix A).[21]

A committee also seems to have handled decisions concerning the stained-glass windows for the principal walkways of the building, on the main floor. The correspondence stream of the 1930s is much slighter and duller, of course, than when Cook was alive, and there is no precise information in the records about how the subjects of these windows were chosen. There is only a single mention of the "Law School Committee" having disapproved of one of the panel's subjects ("contempt of court"); its sketch was returned.[22] The surviving twenty-one subjects grace the windows of three galleries of the glazed cloister within Hutchins Hall (figs. 36–41). The subjects contrast with those of the earlier stained-glass programs. Instead of symbolic emblems made up of arms, seals, and shields, there is here a long cycle of expressive minidramas that represent various legal situations (Appendix B). These are presented as charming, humorous vignettes. The vignettes seem homespun in relation to the lofty clarion of the academic coats of arms in the library and the zodiacal signs and symbols in the Dining Hall. Instead of cosmic cycles of changing seasons and globally famous institutions orbiting about Michigan as an illustrious and immutable center, these scenes illustrate commonplace, down-to-earth incidents taken from the most basic moments of everyday life. The episodes are figured with people who could be seen in the home, indeed in the nursery (fig. 40), as well as on the campus or in the streets of Ann Arbor. In the Hutchins cloister, football is shown not as a universal activity for fall, but as specifically Michigan football, identifiable in the maize-colored jerseys and helmets of the figures in the "Mayhem" window (fig. 37). Mayhem strikes home here with the portrayal of a football player, in a familiar pose, with a tackle aiming to fumble his kick. "Malicious mischief" (fig. 38) shows underclassmen switching street signs at the corner of State Street and Monroe, a location actually just outside the door. Another vignette, "Murder," is visually self-referential as it portrays the entranceway to the actual gallery with the facade of Hutchins Hall itself, complete with its dedicatory inscription and date, in the background (figs. 34–35, 39). The world conjured up by these stained-glass, legal-situation metaphors is not part of a constellation within a wider universe, it is simply the local scene, just outside the door. The windows attempt to do no more than show us exactly where we are in a simplistic legal world, and josh about it. When

studied, the program may seem a spoof or a reaction to the earlier attempts to use stained-glass to express hopes for Michigan's greatness. Although allusion to a medieval claustral environment persists in the architectural armature of the Hutchins cloister, the weight of medieval precedent has been lifted in the windows' iconography and mode of presentation. There is almost no hint of the transcendent aspirations embodied in the thematic cycles of medieval abbeys and cathedrals. Sources are to be found elsewhere, namely in American academic architecture. Yale's smaller but very similar law school library building (by James Gamble Rogers and almost contemporary in construction, 1930–31, to Hutchins Hall), has corridor windows with similar scenes of courtroom barristers (fig. 42). The other buildings by Rogers on the Yale campus, including those of his famed Harkness Quadrangle (1917–21), show vignette windows that further relate New Haven and Ann Arbor.[23] The vignette style was known beyond Yale. It was the glass koiné of the period and it became usual in institutional buildings in the 1920s. Allied with the architectural and sculptural forms of Collegiate Gothic, it swept into academe with them, yet it developed particularly at Yale in Rogers's creations. As Rogers's work was very influential at Michigan, the style came readily to Ann Arbor when the conservative pressures that had governed the program to that point were eased.

As to the making of the glass, Philip Sawyer seems to have overseen the drawing of the vignettes. The cartoons are preserved, and they show a few marginal notes in his hand.[24] These notes deal with artistic matters such as contrast and shading and there are others that indicate when Sawyer finally approved them. A draftsman named "Scotty" is mentioned in two such notes. As these windows were made in the stained-glass shop of Heinigke and Smith of New York, as were the other three groups of glass in the quad, the fact that it has not been possible to trace other references to Scotty at the York and Sawyer firm opens the possibility that the drawings for the vignettes originated in Heinigke's shop, were sent uptown to Sawyer for approval and then to Ann Arbor for Michigan approval, and finally returned again to Heinigke for execution. Heinigke and Smith also made the Yale windows and had a large collection of model sheets at hand.[25] We cannot know what Cook would have thought of these windows. His objections to the clutter caused by "pictures, heads, . . . gewgaws," and "freak things," and his preference for a "classic impression" might have been aroused.[26] But, as with all else in the Michigan quad, he never saw them with his own eyes.

The Jurists of the Hammer-Beam Ceiling

The interior of the Dining Hall had different models than its exterior, and these sources will be discussed in the next chapter. It should be said here, however, that instead of following the elegant fan vaults of King's College Chapel, Cambridge, the Ann Arbor interior derives from monastic refectories and the numerous dining halls of the late Middle Ages based on them. An open timber, trussed ceiling is particularly characteristic of them, and it was taken up in turn by English secular halls, numerous colleges' commons, at both Oxford and Cambridge, and their derivations in this country. The hammer-beam ceiling is a distinctive feature of these refectories, and it was also used for the Law Quad's Dining Hall in Ann Arbor. The specification books indicate that the beams were to be hand hewn, fashioned, and put together by craftsmen at Scrantom's Hayden and Company factory in Rochester, New York, then taken apart, shipped, and put together again by workmen in Ann Arbor. The beam ends were to terminate in the heads of famous jurists (fig. 43, and see fig. 92). They were to be carved in wood by sculptors in Rochester after the models in plaster sent to them from the sculpture studio of Ricci and Zari in New York.[27]

The jurist theme evolved through a series of exchanges between York and Cook chiefly during the winter and spring months of 1924.[28] York had suggested starting with Moses, Confucius, Solon, Aristotle, Cicero, Caesar, Pliny, and Marcus Aurelius. Cook's early list included Solon, Justinian, Grotius, Coke, Blackstone, Kent, Marshall, Webster, and Cooley. He deleted Aristotle, Cicero, Mansfield, and Lincoln, as inappropriate, despite their distinction and fame. The program was eventually cut back on account of cost to Coke, Blackstone, Marshall, and Cooley. York was pragmatic about this and conceded that it would be difficult to see the beam ends as they were to be at such a great distance from the observers below (about fifty feet above their heads), and that simple ornamented beams-ends would thus be just as effective. Carving could also be done later if funds allowed. They agreed on this compromise.

Cook's final choices are interesting. Within the original group of leading jurists, which was to include such lights as Aristotle and Justinian, Thomas McIntyre Cooley was distinguished but definitely local. He had been Jay Professor and then Dean of Law in Ann Arbor before going on to the Michigan Supreme Court. Most importantly, however, he had been Cook's professor at Michigan in the 1880s. Judge Cooley's image could thus function in a typically, medieval, metaleptic way, linking current Ann Arbor students and

faculty with one of their predecessors who had become celebrated as a jurist.[29] As it might be difficult to make out the dark oaken busts high overhead, Cook had York's drawings of them framed and sent on to Ann Arbor to be hung in the Lawyers Club lounge, assuring students of eminence by association.[30] Cook had also intended that an additional dormitory in the quadrangle be dedicated to Cooley, as has already been noted. This would have been another bonding link between Ann Arbor and great jurists of the past. Successful native sons were of course the subjects of carvings at Yale and Princeton, but they were also often likely to be alumni who were benefactors, a thrust eschewed at Michigan, particularly in Cook's case.

Figures in Stone

The Small Corbels as Medieval Metaphors

Three passageways provide entrance to the Michigan quad from the main campus side and add much charm to its South University facade. They point again to Rogers's work at Yale, where Branford Court is similarly accessed. Within the easternmost passage, the ribs of the vault are supported by corbels carved with figures (figs. 44–46). Like the various stained-glass windows, these have subjects that form a program. The four seasons are depicted by a figure holding clusters of grapes as Fall, another posing as Old Man Winter, the youth with flowering vines as Spring, and Summer with grain and sickle (figs. 47–50). An unscaled diagram shows their disposition (fig. 51, E 5–6, 11–12). These familiar iconographic types, with conventional attributes, are based on medieval forebears, although labors rather than seasons are likely to be called to mind, as in such facades as Saint-Denis, Chartres, or Amiens. In the center bay of the east passage's main vaulting, there are four more corbels. They present another demonstration of the way in which medieval iconographic precedent persisted, its systems of thought continuing to lurk even in relatively recent adaptations. Here, instead of labors, which were the appropriate medieval accompaniment to the seasons, as they were to zodiacal signs, the corbels show the university's seasonal activities. Football represents Fall, with the player dressed in a helmet and shoulder pads of the type worn in the 1920s (fig. 52). This particular reference to campus life was commonly carved in Collegiate Gothic sculpture, as on several corbels at Princeton (fig. 53). Hockey represents Winter in Ann Arbor, as the cycle continues; then the catcher with the mit represents Spring baseball; and finally tennis depicts Summer (fig. 51, E 7–10, figs. 54–56).

In the northern bay of this eastern passage, beneath its tower, four figures are presented with attributes of profession; the engineer, with surveying equipment; the architect, with drafting instruments; the artist, with paint pot and chisel; and the jurist, with gown and Mosaic tables of the law (fig. 51, E 1–4, figs. 57–60). If these figures are thought of in relation to medieval iconographic systems, they find no exact counterparts. As a group they may recall representatives of the liberal arts, such as astronomy and Ptolemy, as at Chartres, but the association is not very close. Although a loose reading of the Ann Arbor corbels might interpret them as university professional school disciplines within a wide, seasonally eternal world, their more precise meaning within the sculptural program is complicated by the fact that additional fields of study are represented in the four corbels gracing the archway of the westernmost passage into the quad, at the opposite end of South University Avenue.

This western entranceway (fig. 51, W 1–4), which leads to the cloister arcade and on to the main door accessing the Lawyers Club lounge, is also vaulted. At its northern end, at the base of its tower, are the four additional corbels (figs. 61–64). Their subjects are more difficult to identify. On the basis of their poses and attributes, they seem to represent military science, medical science, commerce or economics (or engineering?), and astronomy (or the explorer). Their subject matter was a puzzle even shortly after they were installed in 1924.

Cook must have been surprised when in August, 1926, he received a packet of 102 snapshot pictures of the quad, kindly sent to him by a gentleman who had been a law student in Ann Arbor at the time of the dedication of the buildings.[31] The writer asked Cook to tell him the identity of the "four gnomes" at the end of the arcaded walk. He added in his letter that fathoming what the designer of the corbels had in mind was "frequently a matter of guesswork" for him. He went on to guess that the identities of these four were (1) "a champion of old" in the northwest corner, (2) "an expert medical witness" in the southwest corner, (3) "Archimedes with his level" in the southeast corner, and (4) "a sailor suggesting admiralty law" in the northeast corner. Cook wrote York asking him for a learned and artistic letter that might be forwarded to the gentleman, explaining the Chinese puzzles.[32] York's guarded reply was that the four were supposed to represent engineering, medicine, astronomy, and law, but he admitted that it took a little "stretch of the imagination" to see the application.[33] York was careful in his answer not to be precise in locating the figures, and we may suspect that he was unsure about all the identities. If we continue with the puzzle and presume

that astronomy (or the explorer, with spyglass and globe, fig. 64) and medicine (with caduceus, fig. 62) were correctly determined, and that the figure called "Archimedes" by the former law student is likely to be York's representative of engineering (fig. 63), then the warlike figure with armor, sword, and shield (fig. 61), which the former law student called "a champion of old," must be York's "law." To have this extraordinarily aggressive figure represent the legal profession does seem, as York says, to require a stretch of the imagination. The warrior stance and threatening expression seem undeniably meaningful. Given the numerous instances of soldiers featured in the ornamental sculpture at Yale, including some that are remarkably similar to this warrior, especially in the Harkness Quadrangle, and given the presence on both the Michigan and Yale campuses, as at other campuses during the recent war years, of housing and training for young soldiers as well as an active Reserve Officers Training Corps (ROTC) program, the figure may indeed represent war or, more broadly, if the group is meant to portray fields of study, military science.[34] If so, perhaps York himself was guessing at its meaning, or perhaps he confused it with the figure representing law among the foursome of the other, eastern passage (fig. 60). Such confusion is not surprising if we consider more carefully the way in which the sculptures came about. They were not the work of an individual who oversaw their entire execution from conception to finish but rather the end result of a long, corporate procedure.

This procedure should be clarified. Before 1924 Cook had really not given much thought to sculpture. He had other things on his mind. He was concerned, of course, about the general impressions the visual qualities of his buildings would make and therefore attentive to matters of architectural style, but he did not pause over decorative details. He probably presumed the buildings would be suitably ornamented with sculpture. He had even said to York, in 1922, that he at first feared the Dining Hall would be too plain and asked for more decorative effect. He was also very much occupied during 1923 and 1924 with the composition of the inscriptions. These were to carry the message of his great venture, and he spent much time on their exact forms. His concentration on these no doubt distracted him from concern about other expressive carving. York himself must have presumed that Cook wanted the buildings appropriately provided with sculptural accoutrements. They were an instrinsic part of Collegiate Gothic style. He had included estimates for models in his budget for sculpture, and he had intended from the outset that there would be a number of special carvings, for he had explained to Cook the procedure of making models when Cook queried their

amazing cost. The specification books make it clear that the sculptors for this project were to be selected by the architects. The sculpture firm chosen was Ricci and Zari.[35]

Carved corbels had become extremely popular in the 1920s, although caricatures in this form were prominent even earlier, for example in the lobby of Cass Gilbert's Woolworth Building of 1913.[36] By 1922 they had become a distinctive part of the York and Sawyer style. They featured in the design of the Bowery Bank, conspicuously located on Forty-second Street opposite Grand Central Station, which was built by the York and Sawyer firm in 1922–23. The squat figures straining and bending beneath their loads, awkwardly squeezed into the peculiar, flaring surfaces of the corbel forms, were usually treated playfully, to inject a profane humor into otherwise prosaic, nondescript forms. Sometimes they were fabulous creatures, ghouls or gremlins, but they were often simply human figures, including portraits, whose legs were stunted or bent into acrobatic poses. Their popularity heightened as the fame of the shop of Ulysses Ricci and Angelo Zari on East Thirty-fifth Street spread. Eight sculptors worked there, assisted by retouchers, plasterers, and casters. Together they perfected the corbel form. Known for their exuberant carvings, thought of as a "revival of Romanesque" historiated capitals, these men were responsible for the Bowery sculptures. Their corbels were such a success that the style of the work came to be known as Boweryesque.[37] Ricci and Zari's shop was therefore York and Sawyer's natural choice to handle the stone sculpture for the Michigan Law Quad project.

No doubt York was not very deeply involved with the designing of the thematic program for these sculptures. Yet York, Sawyer, or another member of the firm, most likely in this case George C. Styles, the draftsman of the October, 1923, drawing showing the plan for the eastern passage (he worked with Henry Diamond who made drawings for the western passage), had written on the sketch for the Law Quad's eastern corbels (fig. 46): "it is suggested that the four seasons of the year be used." The drawing actually shows a conventional, crouching, Boweryesque figure with a musket. Another of his drawings shows a seated court jester, though neither figure ever appeared on the building. These lightly sketched figures were merely a rough guide to standard procedure. The draftsman indicated a generic solution to the corbel spaces in his drawings, and, in the case of the east passage drawing, he added the thematic suggestion of the seasons, with the knowledge that Ricci and Zari would do the rest. They would prepare specific models in plaster. The other drawings have notes at the corbels ("see model") indicating that Ricci and Zari's models for these should be followed by the carvers in

the final stage of the procedure.[38] Although York wrote in May, 1924, that he had gone out to inspect the carvings, he could not have taken much time to puzzle out Ricci and Zari's solution to their thematic commission. It must have looked generally apt and decorative, full of their usual light charm and whimsy.

We do not have records tracing the motivations of the sculptors at the Ricci and Zari shop, but it is surely unnecessary to try to dig so deeply. The iconographies are not intentionally enigmatic in content or meant to be obscure. The seasons is a neutral, open theme that could be configured with many others. It combined appropriately with references to the study and recreation of university life. The inclusion of sports as adjuncts to the seasons inevitably elevated athletics by linking them with the professional schools. The thin allusions to cycles of both medieval labors (via the sports) and medieval arts (via the professions) can be thought of as an imaginative effort to bring academe or Michigan into a tradition of cosmological iconography. Yet, it seems doubtful that the sculptors themselves would have conceived programs venturing far beyond conventional renditions of themes into more high-minded realms of iconography.

As to procedure in the Ricci and Zari shop, typically the sculptors would prepare full-scale mock-ups in clay of decorative sculpture, such as door frames and friezes, as well as figured corbels. These would then be cast in plaster and completed by retouchers. The finished plaster models were then sent to Ann Arbor where stone carvers worked directly from them. The full-scale guides enabled the carvers at the site to know in advance the exact appearance of the desired designs. The interesting aspect of the work in the Ricci and Zari shop is that all the sculptors worked together, one after another taking a turn on the same piece, so that it was impossible to tell where one artist began and another left off. The result was a shop style rather than a personal style.[39] Although there was some variety, the shop had developed stock types for conventional subjects, which helps us to understand how it is that the Michigan carvings so closely resemble others of the same period at other campuses where Ricci and Zari, and other closely related firms, also provided models. Yale, for example, had sculptures of athletics in combination with portrayals of the professions done in the early 1920s. Hence the conventional look of the seasons, athletic activities, and professional studies seen in the small corbels at Michigan. Needless to say the corporate procedure just outlined does not deny the sculptures and their multiple conceivers and creators—their commissioners, including York and Sawyer along with their draftsmen, and their ultimate patron, Cook, and the university behind

him, and their executors at Ricci and Zari, and the stone sculptors, working finally in Ann Arbor—the capacity to express the particular interests and values of their culture. Inevitably these values lodge within the end result, the art itself, even when it is the product of a corporate procedure such as this one. In the case of the Law School corbels, the sculptures speak willy-nilly of the place of the study of law in university life, a theme central to Cook's mission.

The Large Corbels as "Gargoyles"

The larger corbels gave rise to much greater confusion and played a dramatic role in determing the final thematic dimension of the project. It is fortunate that photographs of the actual models prepared by Ricci and Zari survive, as they enable us to reconstruct the history of these six corbels, the most prominent of the quad's sculptures. The corbels articulate the vaulted passage at the main, towered entranceway to the quad's court and thus enliven with figural interest the principal facade of the complex. They support the ribs of the central passage's cross vaults. They are indicated in Henry Diamond's drawing of the first bay (figs. 65–67).[40] The first corbel seen at the right on entering the archway from the street represents President Hutchins (fig. 51, C 2, fig. 68). This is probably the most successful of the corbels, in part because of its corner shape and the pose selected for it. Hutchins's strong features and the explicit directive of his gesture make it seem that it is he who mandates the project. A photograph of his portrait was provided to the modeler-sculptor. Our photograph of the resulting plaster model shows how closely the source was followed (figs. 69–70). The second corbel on the right represents President James Burrill Angell (fig. 51, C 4, fig. 71). This corbel has a broader, more horizontal shape, necessitating the reclining pose, familiar in corbel sculpture. Squeezing a vertical figure into the space of a horizontal field is always awkward and accounts in part for the development of caricatures and playful or fabulous forms in the Ricci and Zari shop and for the curious pose here. Angell's features are again distinctive and were surely based on a photograph, such as the one in figure 72, although in this case we do not have preserved a corresponding photograph of the plaster model itself.

The third corbel on the right represents President Burton (fig. 51, C 6, figs. 73–74). He is shown presiding with a gavel, recalling his administrative role in the office of the president during the actual years of construction. His energetic support of the building program on the campus during the early

1920s has rightly been called the "Burton building boom," as has already been noted, and he was also acclaimed for his highly effective administrative ability.[41] Figure 74 shows the photo portrait of him that was probably provided to the sculptors. The plaster model for his sculptured portrait is seen in the center of figure 75. It is marked "40" to cue it to the architectural drawings for the passage. At the left in this same photograph, among three of the original sculptors' models for the corbels, can be seen the visage of Shirley Smith, shown with glasses and a book and cued as no. 43 (for C 1, fig. 75, cf. fig. 76). Smith was secretary of the university during this period and central to the financial negotiations with Cook from the very beginning of the project.[42] At the right in the modeler's photograph, cued as no. 39 (for C 5, fig. 75, cf. fig. 77), the figure with a mustache, is Jerome Knowlton. He was Professor of Law, then acting dean, and finally dean of the Law School (1891–95). He was Hutchins's direct predecessor in this last office. However, although Knowlton had been a dean, his fame really rested on his career as a much beloved teacher. A photo of him from 1888 identifies him with a note and the words "the quizzer," indicating the role for which Knowlton was so well known.[43] Finally, there is also preserved the photo of the plaster model for the central corbel of the passageway, representing Dean Bates, its setting cued as no. 41 (for C 3, fig. 78, cf. fig. 79). His distinctive features, including his hairstyle and his glasses, are shown in the model.

The left side of the central passageway today does not show these latter three figures, not Secretary Smith, nor Professor Knowlton, nor even Dean Bates. Smith and Knowlton were intended for the two corners, Smith at the north end (fig. 51, C 1), and Knowlton at the south end (fig. 51, C 5), as is attested by the setting marks on the modeler's photograph (nos. 43 and 39) and by the shape of the corbels. Instead, the actual south corner figure today is Erastus O. Haven, president 1863–69, with his squarish beard and his especially sharp nose (figs. 80–81). And the actual north corner figure today is Henry Simmons Frieze (who was acting president 1869–71 and again during Angell's absence, 1880–82), with his spectacles and full, wiry beard (figs. 82–83). At the center corbel today we see the famous Henry Philip Tappan, Michigan's first president, 1852–63, whose forelock is particularly recognizable (fig. 84). Probably a photograph of an engraving of him (fig. 85), rather than the Bitter bronze in Tappan Hall, was used by the modeler in replicating his features.[44]

Clearly there was a change of program with regard to the figural sculpture for this passageway. We need not hypothesize about it. The documents record the change exactly. During the spring of 1924, Cook had been keenly

formulating the inscriptions and was not concerned with sculpture. He was of course distant from Ann Arbor when the corbels went up during the summer. Just as the project was nearing completion, he learned of these images. He referred to them as gargoyles. On August 5, he wrote to York of his astonishment at the figures and asked who had selected them and on what principle the selections were made, wondering how York, who knew little of the history of the university, could have managed this. He would not have minded presidents, that would have been one thing (President Tappan, for example would be very acceptable), but the inclusion of a secretary, who was not even a lawyer, and a dean—"who has had predecessors and will have successors"—was another. He considered it quite inappropriate to have these officials magnified in a building of such lofty conception. He repeated his opposition to the forms, saying that he had rejected similar ideas for Martha Cook when there were schemes to "clutter it up with pictures, heads, inscriptions and gewgaws." He repeated his injunction not to destroy the classic and time-hallowed impressions given by every other part of the building with such incongruities. He asked York to remove the offending images at once and to limit the heads to portrayals of the presidents.

The very next day York responded, gracefully as always, blaming himself for the mistake, regretting his thoughtlessness and assuring Cook that the work would be redone at York and Sawyer expense. He identified the six subjects as Presidents Angell, Hutchins, and Burton on one side and on the other Shirley Smith, Dean Bates, and Professor Knowlton. Cook wrote back directly asking, "Who is Professor Knowlton? I don't recollect ever having heard of him." It was Cook's agent, John Creighton, who described Professor Knowlton and noted that he was known as a very good instructor and that he was well liked by students. When Cook learned, to his relief, that the inappropriate heads could be removed, he asked York to have that done at once and added that these heads might just as well be put into a sack and thrown into the Bosphorus. In a few more days, in early September, York sent photos of the other three presidents to replace those "sunk in the Bosphorus," as he put it. Cook asked what the busts of these three, Presidents Tappan, Haven, and Frieze, would cost, and York responded, again, that there would be no charge. However, he was eager to proceed quickly with the revisions, before Starrett's men vacated the site.[45] It was fortunate indeed that to this moment the University of Michigan had had just six presidents.

The newspapers got hold of the story about the figures that were cut out and replaced. These accounts interestingly inflated the story's interest, say-

ing that the offending figures had been smashed to bits with a heavy maul, conjuring up a melee. One can only read with sympathy Shirley Smith's amusing account of what would thus have been the shattering of his own stone portrait; he quoted a comment attributed to one of his friends, a professor and a wag, who said that he had rushed over and picked up an ear out of the rubble so that he might have the ear of the dean in moments of importance. Dean Bates's admirable response was reputed to be that he, like the Roman stoic, preferred to have people ask why the dean was not there than for them to wonder why he was.[46]

The change of program entailed interesting ironies. In line with his usual thinking, York was no doubt simply following conventional iconographic schemes in his direction for the first plan. As at Yale, Michigan would originally have had in these corbel sculptures a group of representative types: a distinguished past president, James Burrill Angell (whose son, James Rowland, was at the very moment president of Yale); the president in office at the time of the conception of the building project and its "godfather," Harry Burns Hutchins; the president at the time of its execution, Marion Leroy Burton; plus Secretary Shirley Smith, as the facilitating university financial official; Dean Henry Moore Bates, as the current administrator of the law school; and Professor Jerome Knowlton as a famous early teacher within its doors. All but Smith had law degrees. This group represented those who had brought the law school to its current state of distinction. They were its generators, so to speak, and could be seen therefore as a modern echo of the *Christophores* of a medieval portal embrasure. The change from these types to the six presidents was a shift from the traditional medieval idea of progenitors (still lurking in the original program though no doubt without anyone being particularly aware of it) to the history of the university in general, a shift from an emphasis on causation to a simple, additive nod to the university's presidential history. Ironically, this change meant that the new group included pastors of churches, with the addition of the forms of Tappan and Haven, and professors of rhetoric and Latin, in the forms of Haven and Frieze, rather than a selection of those people who best represented the generating forces that had brought about the building program, the underlying idea of the earlier plan. Always valuing prestige and eminence, Cook preferred the six presidents, and that scheme obtains today.

Those who know the history of the university also know that as Knowlton "the quizzer" was displaced, his succession by Frieze, at the other corner of the passageway, meant that one great teacher was replaced by another, for Frieze had been Angell's beloved teacher in Rhode Island during

Angell's formative years and was later brought by him from Brown to Michigan. They now pose opposite one another, permanently linked both in their roles as teacher and student and as successors in Michigan's president's chair.

A second irony has to do with the presence of Tappan. The bronze portrait of him by Karl Bitter from 1912 is in Tappan Hall, just across the street from the Law Quad's main entrance.[47] One of Tappan's early, important acts as president was to dissolve the dorm system on campus and send the students to residences in town as he attempted to emulate in Ann Arbor the systems of European universities, particularly German university designs. Cook's aim was the opposite, to bring the students into a special, on-campus residential environment in his quadrangle.

The silences of the central tower passageway program are also eloquent. There is no reference to either architect or donor. It was usual to have both. The famous architect Cass Gilbert is shown on a corbel in the entry corridor of his great Woolworth Building in Manhattan, and James Gamble Rogers is shown in the sculpture of the main arch leading to his Harkness Quadrangle on High Street at Yale. Ralph Adams Cram's portrait is seen at the entrance to his chapel at Princeton. It was a medieval custom, from the time of Odo, who worked for Charlemagne, and many medieval precedents for the custom survive. When the first dedicatory exercises were being planned for Ann Arbor, Bates wrote Cook that despite his urging York had refused to speak at the ceremony. Bates added that York's buildings would no doubt be the most eloquent address of the occasion. Some time later as the festivities came into view, Cook urged York to go, to which York responded that he had not even received an invitation to this gala gathering. York also wrote of his disappointment that there was no mention of the York and Sawyer firm in the yearbook put out by the students just after the dedication in which the buildings were acclaimed.[48]

The silence of the central tower passageway is especially eloquent with regard to the donor. The Harkness family is represented thrice in sculpture at the entrance to the Harkness Quadrangle at Yale (the honoree Charles and his brother Edward, in addition to Samuel Herbert Fisher, representative for Mrs. Stephen V. Harkness, who was chiefly responsible for the munificent donation), and many such examples could be cited. In the Middle Ages it was common practice. At Merton College, Oxford, for example, the windows of the chapel were given by Master Henry of Mamesfield, whose figure appears in the stained glass twenty-four times.[49] There is no figural reference

here, however, to the Cook family nor to the "mythical" donor William Wilson Cook, austere son of Michigan.

NOTES

1. Some thought was given to a statue of Judge Cooley for the center of the quadrangle at Michigan, but that was dropped. MHC 58-11, May 8, 1924, 59-7-17, August 3, 1925, 59-7-8, August 14, 1925, 59-8, July 23, 1929. See also note 26.

The term *gargoyle* was of course a misnomer in that gargoyles, as the word indicates, are properly conduits for draining water, usually from roofs, and are waterspouts. However, the word was commonly used during the 1920s, as today, to refer to curious sculpture in general.

2. Robert Gambee, *Princeton* (New York, 1987), p. 221; *The Gargoyles of Princeton University* (Princeton, 1987); Robert Dudley French, *A Guide to the Memorial Quadrangle at Yale University* (New Haven, 1931), pp. 8–9; George Nichols, "The Harkness Memorial Quadrangle, Yale University," *Architecture* 44 (October, 1921): 294, 296; James Gamble Rogers, "The Memorial Quadrangle and the Harkness Tower at Yale," *American Architect: The Architectural Review* 120 (October, 1921): 309; idem, "The Harkness Memorial Quadrangle, Yale University," *Architecture* 44 (October, 1921): 296.

3. See the discussion of Cook's emphasis on "pinnacles" in chap. 4.

4. University of Michigan, Engineering Services, Archives (UMESA). Departing from the cartoons, the seals of the university and the state were exchanged in their actual settings. For the Cambridge windows, see Hilary Wayment, *King's College Chapel, Cambridge, The Side Chapel Glass* (Cambridge, 1988).

5. French, p. 22; Rogers, "The Memorial Quadrangle"; idem, "The Harkness Memorial Quadrangle."

6. UMESA. The drawings are signed in the title block by initials only ("H.R.D."); I infer this to mean Henry R. Diamond, a member of the York and Sawyer team. Along with other members of the firm, he signed a menu at the York and Sawyer Christmas party in New York on December 21, 1925, in a very similar hand. It was a custom of the firm for its members to so list themselves on that occasion. He was responsible for a large number of drawings for the project during 1923 and 1924. AA (memorabilia). See note 16.

7. MHC 59-7-16, May 12, 1930.

8. Philip Sawyer, *Edward Palmer York, Personal Reminiscences by His Friend and Partner* (Stonington, Conn., 1951), p. 26. Note also the point made by Sawyer, with numerous attestations throughout this book, that York himself almost never drew a line. York's discriminating eye, however, was responsible for the ultimate quality of many of the drawings prepared by his draftsmen in that York made repeated suggestions to them for critical changes during his frequent reviews of their work.

9. Rogers, "The Memorial Quadrangle," no. 2379, p. 309; French, p. 11. The inscription over the exterior entrance to the Dining Hall from the court is FREE INSTITUTIONS. PERSONAL LIBERTY. The inscription at the top of the wood paneled doors, over the interior entrance, is the University of Michigan's motto: ARTES. SCIENTIA. VERITAS.

10. The portrait was painted in 1916–17, along with another of Cook's mother, Martha (which hangs in the building named for her), by French portraitist Henry Caro-Delvaille. A miniature of Martha, along with John Potter Cook's desk and other implements of his enterprising life, can be seen in the background of the painting. Enclosed within the frame and visible in its lower right corner is the letter Cook's father wrote to him on his seventeenth birthday. See the discussion of these in chap. 2, nn. 9, 13.

For various drafts in the preparation of the inscription, see MHC 59-7-17, September 20, 1929, January 15 and May 14, 1930.

11. MHC 59-7-16, January 28 and 29, 1930.

12. MHC 59-7-16, May 12, 1930, see also May 23, 1930. Note the contrast here with York. In his biography of York, Sawyer makes a sharp point about his own love of drawing in contrast to York's more detached (much reading of Cellini and much deep thought while gazing out the window), literary approach to design. Sawyer was an especially competent engraver. His designs for federal currency and other engraved items survive among his sketchbooks and memorabilia. AA.

13. MHC 59-7-16, May 12, 1930. In contrast to some of the colorful religious windows of Oxford and Cambridge, these "spots of color" at Michigan seem very restrained in their small scale, secular reference, and emblematic, abstract forms.

14. MHC 59-7-17, May 14, 1923, 59-7-16, May 23, 1930.

15. MHC 59-8, May 22, 1930. The last letter that Cook wrote during his life that I have been able to trace was written May 28, 1930. It deals with his pleasure that Alexander G. Ruthven, recently named president of the university, was then personally in charge of the university's interests in his project.

16. The letter with its list is published in an unsigned article, "An Artisan Is Inspired by His Task," *Michigan Alumnus* 38 (October, 1931): 5–6, 14. The *Specifications* book for the Legal Research Building indicates that English cathedral glass of varied light tones was to be used for the windows in addition to the ornamental inserts of shields with their seals or arms, and that the entire cost of glazing was to be $30,093. MHC 60, August 19, 1929, p. 151. The *Specifications* book for the Dining Hall also records the use of English Cathedral glass; in this case a sum of $2,500 was provided for the ornamental medallions used as inserts. MHC 59-23, March 19, 1923.

17. I find only the two from China indicating any institutions east of Vienna; I find none from Italy except Rome; thus, Bologna is excluded!

18. Jean F. Block, *The Uses of Gothic, Planning and Building the Campus of the University of Chicago, 1892–1932* (Chicago, 1983), p. 100 (the east screen has Oxford, Cambridge, Paris, Berlin, Petrograd, Bologna, Tokyo, and Calcutta; the west screen includes Harvard, Yale, Johns Hopkins, Columbia, Michigan, Wisconsin, California, and Chicago).

19. Cook was always fond of Hutchins and was aware that his helpful ministrations were critical to the success of his venture. Hutchins had presented Cook's letters of gift several times to the regents. He managed, despite daunting weather conditions and his own fragile health, to be present at the last important presentation on January 11, 1929, when the John P. Cook Dormitory and Legal Research Building were committed. This was just days after York's death. Philip Sawyer and his associates Bene-

dict and Greene, representing the architectural firm, presented their blueprints. Dean Bates and librarian Hobart Coffey represented the Law School. As early as 1924 Cook referred to Hutchins as "godfather" of the project and used the term repeatedly thereafter. MHC 58-7-7, February 7, 1924. The decision to honor him, by naming the new building Hutchins Hall, was made even before his death. Edson Read Sunderland referred to this decision of Cook's in a letter to him on January 7, 1930. Alice Sunderland Wethey and Elizabeth Sunderland Collections, Ann Arbor. My warm thanks to the Sunderlands for their courteous assistance to my researches.

The York and Sawyer working drawing for the entrance to Hutchins Hall from the courtyard does not show the inscriptions in their final form (figs. 34–35). The actual tablet has HUTCHINS HALL THE UNIVERSITY OF MICHIGAN LAW SCHOOL ANNO DOMINI MCMXXXII. The small inscriptions in the spandrels of the arches associate Cook and Hutchins. At the left doorway they are WWC 1880, LLB [18]82 and at the right HBH 1871 LLD 1920.

20. MHC 60-14, January 14, February 4, March 4, 10, 12, 17, and 23, 1932. Such removal was of course at great expense and hazard to the weather resistance of the windows. It must be remembered that exciting modern buildings, with broad stretches of glass, allowing ready viewing of wide sweeps of nature, were then being built by progressive architects in America.

21. MHC 60-14, January 29, April 26, June 13 and 21, and July 1, 1932, 60-15, July 5, 7, and 8, 1932. See also the views on architectural style argued by Hobart Coffey, "The Law Quadrangle of the University of Michigan," *Law Library Journal* 25 (1932): 266–77.

22. MHC 60-14, March 21, 1932.

23. Rogers, "The Harkness Memorial Quadrangle," p. 291. Yale's law building also has such vignettes in relief sculpture, for example, showing policemen chasing masked burglars. See also Mary C. Withington, "The Decoration of the Sterling Memorial Library," *Yale University Library Gazette* 5 (October, 1930): 17–34, 81–123.

24. MHC Unbound Materials. See also note 6.

25. Illustrations of assistants in Heinigke's shop, Mr. Motherwell and Mr. Withers, making use of such designs appear in *Michigan Alumnus* 38 (October, 1931): 5–6, 14.

26. UMLSA August 4 and 13, 1924.

27. MHC 59-22, May 25, 1923.

28. UMLSA February 26 and March 7, 1924; MHC 58-11.

29. Among the numerous medieval analogues to this strategem are examples such as Ravenna's St. Apollinaris, in the company of the apostles, and, similarly, St. Martial of Limoges.

30. MHC 58-11, April 22, 1925. I have not been able to trace the present location of these drawings.

31. This would likely be Hiram Bond, who had helped with the editorial work on *The Brief*, a student yearbook published in 1925.

32. MHC 59-7-9, August 21, 1926.

33. MHC 59-7-9, September 1, 1926.

34. Rogers, "The Memorial Quadrangle," p. 308. Yale's sculptures also included

portrayals of the professions, in their case business, law, medicine, and ministry, on the Harkness Tower. Nichols, "The Memorial Quadrangle," 296, 301; Rogers, "The Memorial Quadrangle," 310.

Our National Cathedral in Washington, D.C., has a corbel carved with an amusing rendition of a harried commuter, rushing off to his business activities; in hand is his briefcase as attribute of his profession. No program has yet been discerned, but it is of interest that some of the carvings there were done during the 1920s and 1930s. *The Cathedral* (Charlottesville, Va., 1988), p. 115; Richard Feller and Marshall Fishwick, *For Thy Great Glory* (Washington, D.C., n.d.). Various athletic activities are portrayed in the stained-glass windows of the Cathedral of Saint John the Divine in New York City. Although installed in 1951, they were designed by David Bramnick in 1926. The sports include hockey, football, basketball, tennis, boxing, fencing, skiing, bowling, and automobile racing; they appear to have been programmed as a loose assortment of athletic activities rather than as professions or as references to the seasons. They are grouped about the image of the famous hunter, St. Hubert. Other professions are presented in the windows of the side chapels. Rev. George W. Wickersham, II, with John W. Harris, *The Cathedral Church of St. John* (New York, n.d.), p. 35.

35. The record of Cook's payments to them ($13,245) and some correspondence survives. MHC 59-21. For a brief summary of Ulysses Ricci's career, see P. Falk, ed., *Who Was Who in American Art* (Madison, Ct., 1985), p. 515.

36. M. Shapiro, *The Dover Walking Guide, New York* (New York, 1982), pp. 24–25, fig. 24.

37. *Progressive Architecture* 46 (December, 1965): 136–41. Renditions of the professions similar to those in Ann Arbor appear in the Ricci and Zari work at the Bowery.

38. UMESA D 371, D 378.

39. *Progressive Architecture* 46 (December, 1965): 136–41. Photographs of the models prepared for the Michigan corbels survive. They have noted on them position marks that key them to the architect's working drawings. MHC 64. Of course, the collaborative procedure described here for sculpture is also characteristic of the preparation of drawings in an architectural firm's shop.

The Imperial Stone Company of Bedford, Indiana, was in charge of the cut stone work in limestone, and Plymouth Quarries Incorporated of Boston was responsible for the granite ashlar for the buildings of the first campaign (1923–24). We do not have details regarding the identity of the stone carvers who worked on the corbels in Ann Arbor. They would presumably have been part of the Bedford team or an unnamed group of carvers specializing in architectural sculpture. York described the procedure of making plaster casts and shipping them to the job for the carvers, and he distinguished between the craftsmen who handled carved cabinetry in wood, which was done in the wood shop (primarily at the Hayden and Company atelier in Rochester, New York), and the stone carvers who worked at the site. In the latter case the stone was roughed out at the quarry and then finished in place on the building, following the exact guide of the plaster models. MHC 59, October 23, 1923. See also fig. 24. The *Specification* book spells this out as well. MHC 59, March 19, 1923, pp. 48–51, 54–55. Michele Bogart describes this specialization in *Public Sculpture and the*

Civic Ideal in New York City 1890–1930 (Chicago, 1989), pp. 78–80. This modern method is at variance with most Romanesque carving of the twelfth century, which was created primarily in the sculptor's shop, which was normally located at the site, before being fitted into place on the building. With the second Ann Arbor building campaign, the stoneyard of Acme and Company was employed, allowing some stone to be prepared in the stone yards in Detroit. MHC 59-7-13, October 25 and November 12, 1929, 60-6, May 12, 1930. The Daily Report of the contractor for the second campaign, James Baird, notes payments to three carvers on the site; these would have been some of the architectural carvers employed by the J. Donnelly Company to execute the carving over doors and windows, MHC 60-6, May 12 and 15, 1930, confirming the specifications for both the John P. Cook Building and the Legal Research Building, MHC 60-2, pp. 55, 94–96, 60-3, pp. 59, 117.

Corrado Parducci, the Detroit sculptor who supplied the reliefs for the facade of the Horace H. Rackham Building at the university in 1936–37, MHC 5-D, described the procedure his shop followed in the making of plaster models during the late 1920s. John B. Cameron, *Meadow Brook Hall: Tudor Revival Architecture and Decoration* (Rochester, 1979), pp. 4–7.

The reliance on stock formulas for decorative low-relief sculpture is evident in the series of shields showing standard symbols of the law that ornament window areas and buttresses of the Legal Research Building and Hutchins Hall. Four (small) and five (large) types are repeated in slightly varied patterns that are occasionally interrupted for accent with more elaborate eagles and the Michigan and national seals. Related formulas were used for the shields ornamenting the gables of the Lawyers Club during the first campaign. Forty-eight shields—representing the seals of the nation's states—ornament the upper perimeters of the four towers of the Legal Research Building, three to each side, twelve for each tower.

As to the construction workers, they were employees of the contractors, being Starrett's crew for the first campaign and Baird's for the second. With the approval of university administrators who hoped that educational benefits would come from the practical experience, a few engineering and architectural students were used by Starrett in the construction process during the summer of 1923. MHC 59-19, July 31, 1923, 59-24.

40. UMESA, D 121, with Ben Moskowitz, October and November, 1923.

41. Although Burton saw the first-phase buildings completed and witnessed the opening of the residential Lawyers Club to students in the fall of 1924, he died suddenly at the beginning of the next year, before the actual dedication ceremonies took place. Cook had invited President Burton and Dean Bates to dine with him in New York on November 13, 1924, for discussion regarding the continuation of the project. MHC 58-11, October 20, 1924. Burton then died on February 9, 1925. The dedication ceremonies were held June 13, 1925. See Howard Peckham, "The Burton Boom," *The Making of the University of Michigan* (Ann Arbor, 1967), pp. 139–56.

For brief accounts and illustration of the new buildings published at this time, "Lawyers Club, University of Michigan, Ann Arbor, Michigan, York and Sawyer, Architects," *American Architect and Architectural Review* 126, no. 2459 (November, 1924):

488, pls. 173–76; "The Dedication of the Lawyers Club," *Michigan Alumnus* 31 (1924): 754–58; Wells Bennett, "The Law Courts Building, University of Michigan," *Architecture* 52 (July, 1925): 236–42.

42. Shirley Smith had also overseen the university's acquisition of land for the building campaigns. He accompanied President Burton on a number of trips to New York to confer with Cook about the project. He was a Michigan graduate and had been a classmate of one of the Starretts (of Starrett and Company, the New York and Chicago contractors), who were the engineers in charge of the first campaign. See note 39.

43. MHC. Photo Archive.

44. MHC 59-7-7, September 3, 1924. See also Burke A. Hinsdale, *History of the University of Michigan* (Ann Arbor, 1906), pp. 218–19, 268, 284; Wilfred B. Shaw, *The University of Michigan* (New York, 1920), p. 73; idem, *A Short History of the University of Michigan* (Ann Arbor, 1937), pp. 52, 68.

45. MHC 59-7-7; UMLSA, August 5 and September 16, 1924.

46. The story became a legend. *The Detroit News*, April 29, 1934; Shirley W. Smith, *Harry Burns Hutchins and the University of Michigan* (Ann Arbor, 1951), pp. 205, 304–6.

47. Margaret Cool Root, "Tappan, Bismarck, and the Bitter Connection: Reflections on Men and Their Dogs in the Artful Memory," *Rackham Reports* (1986–87): 17–46.

48. Shapiro, pp. 24–25, fig. 24; French, p. 13; *Princeton Alumni Weekly*, February 20, 1991, 18; MHC 58-11, September 29, 1924, 59-7-8, June 9 and 10 and July 22, 1925; *The Brief* (Ann Arbor, 1925).

49. French, p. 13; Christopher Brooke and Roger Highfield, *Oxford and Cambridge* (Cambridge and New York, 1988), p. 67.

Collegiate Gothic Architecture in America: Sources for the Cook Quadrangle

Cook's thinking about historical sources for the architecture of his proposed venture was vague. As he was a strong Anglophile, he was convinced from the outset that his buildings should evoke Oxford and Cambridge, but he realized that the details of the evocation would only emerge as plans progressed. When the design for his law quadrangle began to take shape, from the fall of 1921 on, it was clear that he also wanted the venture to incorporate the idea of a residential complex, patterned after the English Inns of Court system, that would combine living, dining, study, and professional training in one ensemble, as has already been commented on. He was confident that following the selective admission systems of Oxford and Cambridge would ensure a "superior class of men," and he believed that providing them with stately architecture and comfortable club-like quarters within handsome structures, reminiscent of the manor houses of English gentry, would help groom them as gentlemen while developing their capacities for professional leadership.[1] While his ideology was emphatic, implementation remained emergent.

As to the use of specific Oxford and Cambridge models, the record is less clear. In his correspondence with York, Cook referred to clippings and postcards with views of Oxford and Cambridge buildings that he was sending on for York's reference. Unfortunately, for the most part these do not survive. Cook was also aware that exact replication of any of these would be neither possible nor desirable. The Inns of Court and most Oxbridgian ensembles included and often were planned about a chapel, and that was not desired for Michigan. The chapel form, however, could be used for other purposes, as had already been demonstrated at Yale, where the Old Library was mod-

eled on King's College Chapel, Cambridge.[2] Such chapel designs could be adapted even more readily to the function of a dining hall, as Ralph Adams Cram had demonstrated at Princeton with his dining room for Proctor Hall in his Graduate College ensemble, built in 1913.[3] There is evidence from as early as 1919 that York was studying the Princeton model. In a letter of March 11 of that year Cook wrote to York about his planned residence hall in Ann Arbor: "I understand that the proposed enlargement of the dining-room is in accordance with an idea you gathered at the Princeton dormitory, namely, by increasing the size of the room a few feet the seating capacity is greatly increased."[4] In 1921 Cook evinced continuing interest in Princeton's architecture by sending York a news clipping that noted that Princeton's architects, Day and Klauder, would soon build several new dormitories there in the Collegiate Gothic style and that these would closely follow buildings at Cambridge and Oxford.[5] Holder, Hamilton, and Madison Halls at Princeton had been constructed by Day and Klauder from 1910 to 1916, contemporary with Cram's graduate college buildings, which included Proctor Hall with its dining room and Cram's much admired Cleveland Tower, which epitomized the emphasis Collegiate Gothic gave to the English perpendicular style. All these Princeton structures had preceded by a few years James Gamble Rogers's work at Yale on the Harkness Memorial, with its six internal quadrangles, from 1917 to 1921.[6] Within the Harkness quad was a commons and a dining room, of interest in relation to the Michigan Dining Hall, and in the Harkness Memorial Room of the Harkness Tower, Rogers had created a modern version of the fan vaults of Cambridge's King's College Chapel (1448–1515).

The adaptations of Oxbridgian quadrangles that had already been developed at Princeton and Yale for American university students were therefore close at hand. They were more practical models for close study than Oxford and Cambridge themselves. Both were readily accessible from Manhattan. In his later years, York lived in Princeton and would have seen the buildings daily as he boarded the train at the campus station near Blair Arch. In addition, both York and Sawyer were friends of Yale architect James Gamble Rogers. They all belonged to the same club on Forty-third Street in New York, the Century Association, and it may be presumed that they saw one another relatively frequently at lunch there. They were in touch regularly about their respective building projects.

In addition to such professional contacts, the associations with Yale extended to direct emulation. As Cook was deciding on final matters for the first phase of the project during the fall of 1922 and the spring of 1923 and wrestling with the challenging expense of stone, York compared the costs of

the Ann Arbor and Harkness quadrangles (October 5, 1922). He then brought to Cook, for his review and selection, samples of several types of stone used in the Harkness work at Yale (October 20, 1922). Cook chose the Plymouth seam-face granite used there by Rogers. The subsequent specification books for the Lawyers Club have specifically written into them the requirement that "the facing of all exterior walls of the buildings . . . shall be of Plymouth seam-face, ashlar granite with interrupted courses . . . similar to that used on Harkness Memorial, New Haven, Connecticut," and again that "all granite shall be Plymouth . . . seam-faced granite ashlar with interrupted courses and finished with pitched beds and builds, of sizes, shapes and method of laying as that in the Harkness Memorial."[7] And, of course, both projects used limestone from Indiana. Cook had even considered using the same general contractor, Marc Eidlitz and Son, who had worked for Rogers at Yale. Eidlitz had provided early estimates for Cook's Ann Arbor quadrangle, but Cook actually chose another firm, Starrett and Company, when the contracts came to be let. The same stained-glass maker, Heinigke and Smith, was employed at Yale and at Michigan. Cook had also considered using Irving and Casson, the very firm employed at Yale for the interior paneling and furnishing of the quad buildings, but found their estimates high and settled instead on Scrantom's Hayden and Company.[8]

Although models at Yale were continually invoked during the first phase of the Michigan project, they came more clearly into York's sights during the second phase as he turned to the monumental challenge of the Legal Research Building, the quad's library, which was in process from 1926. Both Harvard and Yale were planning new libraries at that time. York repeatedly referenced the Yale model. Rogers's Sterling Memorial Library was constructed in 1927, and his plans for the Sterling Law Building (of 1930–31), which was to include a smaller law library, were being developed at the same time that York was working on the Michigan library design, during 1927 and 1928. York mentions a number of visits to Yale, saying that he had consulted in New Haven with his friend Rogers and had gone over preliminary drawings for the Yale law library with him there. York indicated (in July, 1927) that he also had copies of Rogers's library plans. By September of that year, Hobart Coffey had gone over the Yale plans as well. In November, 1927, Cook stated that the Michigan library was to be based on the Yale library, and he repeatedly requested that York show his own plans to the Yale librarian and dean of the Yale Law School and ask for their comment. York did that, taking the opportunity to query his friend Rogers specifically about the Michigan project. He took the York and Sawyer drawings for the Michigan library

to New Haven again on March 22, 1928, to go over them with Rogers.[9] After York's death, Sawyer repeated this action. Sawyer had made a number of changes in the plans. He took the drawings to Yale in December, 1929, to consult anew with his friend Rogers, just after excavation on the library in Ann Arbor had commmenced. The Yale law buildings went up during 1930 and 1931, and Hutchins Hall, Michigan's final building in the complex, came just on their heels, being under design and construction from 1931 to 1933. The documentation for Michigan falls off at this time, however, except for a memo in the file that compares Hutchins Hall directly to Yale's Sterling law building with regard to their relative capacities. Despite being guided as they were by different patrons, at least one of the same inscriptions appears in both the Ann Arbor and New Haven law school buildings (figs. 86–87): Holmes's THE LIFE OF THE LAW HAS NOT BEEN LOGIC, IT HAS BEEN EXPERIENCE. It is carved at the entrance to the cloister gallery of Hutchins Hall and on the exterior of an entrance to the dormitory building from the inner quadrangle at the Yale law school. In sum, Yale's importance both as a conceptual source for the Michigan architecture and as a refining influence on its implementation in Ann Arbor was continuous and close from the beginning to the end of the Cook project.

During the early phase of the Michigan venture, numerous other sources are also evident in York's work, and they extend widely beyond Rogers and Yale to include other ivy league campuses along the Eastern seaboard. York had made an early reference to Princeton in 1919 and he continued to look closely at architecture there. In January, 1923, he reported to Cook regarding a special trip made to Princeton, the University of Pennsylvania, and Bryn Mawr to study their respective campus buildings.[10] All three of these campuses had fine Collegiate Gothic architecture, and all three were distinguished by having excellent examples of towered gateways: Blair Arch at Princeton (1897), Pennsylvania's Memorial Tower (1895–1901), and Bryn Mawr's towered archway at Rockefeller Hall (1897). All were designed by Philadelphia architects Cope and Stewardson.[11] These impressive arched entranceways with their vaulted passages flanked by crenellated, octagonal towers of massive stone summoned up English aristocratic associations as they secured the quiet calm of their campuses and separated them from the bustling worlds of the towns outside. They were modeled on the Tudor gateways of English colleges, castles, and manors. Examples abound at Cambridge: King's Hall (King Edward's Tower, 1424–37), Queens' College (The Great Tower), Trinity College (The Great Gate), and St. John's College (The Main Gate, early sixteenth century). The towered gate may also be seen inter

alia at Oxford, Eton, and Hampton Court.[12] York's towered gateway, used for the main entrance to the Ann Arbor Law Quad, echoes a number of these, being closest to Princeton's Blair Arch and Bryn Mawr's Rockefeller Hall (figs. 19, 65, 88–89). The Ann Arbor version, however, has small Tudor domes atop the towers and uses scrolled parapets rather than battlements, along with central oriel windows; it is similar in these features to Phelps Gate at Yale (by Charles Haight, 1895) and to Eton College, both of which were in part modeled on the Hampton Court Clock Tower, Anne Boleyn's Gateway (1535–36), and the west face of the Tudor Hampton Court complex (1540).[13] York incorporated in his design English Renaissance elements, mostly Elizabethan, and also Tudor and Jacobean motifs, such as sculptured gables, bundled rectangular chimney pots, set point to point (to allow a thin sliver of blue sky to define their sharp contours), and broken pediments. The Lawyers Club lounge shows more continental, baronial parapets, cartouches with scrolled headpieces, and heavy brackets for its oriels. It includes the use of some classical orders, such as Tuscan engaged columns with a Doric frieze of triglyphs and metopes at the State Street entranceway. These Renaissance and general Beaux Arts elements are reminiscences of the McKim, Mead and White origins of the York and Sawyer shop. They were especially appropriate to the Lawyers Club residential buildings, where they enhanced reference to a landed gentry in a castellar and country-house milieu and to the well-to-do clients of the McKim, Mead and White firm in New York.[14] These features had become established during the first decades of the century as stock items in the decorative vocabulary used for ivy league campuses, where they were freely mixed and imaginatively combined. Thus a search for the models followed in Ann Arbor's first Law Quad campaign becomes a lesson in eclecticism. Rather than single specific models, the York and Sawyer shop, under the direction of York for this project, creatively selected, combined, and adapted earlier motifs and manners to the Law Quad's needs and to Cook's ideological vision.

The Dining Hall is perhaps the closest of the first campaign buildings to the model that has been claimed for it, that is, King's College Chapel at Cambridge University (frontispiece and fig. 90), built 1448–1515 by Reginald Ely, John Wolryche, Simon Clark, and John Wastell.[15] The Dining Hall's exterior follows the English perpendicular Gothic style of the chapel, particularly in its eastern and western elevations with their prominent towers and full glazing and with their emphatic vertical window tracery. Along the flanks, York followed the proportions of the tracery mullions, the positions of the buttresses, and the form of the pinnacles, though he did not include

recesses equivalent to the model's small chapels. While he eliminated the series of exterior statues on the buttresses, he retained a decorative string-course. The towers and turrets also show points of similarity, and though the Michigan towers are less tall and slender, they follow the polygonal shape at Cambridge and echo the ogee profile of the Tudor domes (fig. 91). However, they lack the detailed ornamentation of the earlier building, such as the exquisitely carved Tudor rose, the Beaufort portcullis, and the pierced screens of the lancets, which yield a more fragile look, one that dissembles as it features the white Yorkshire (Huddleston?) limestone.[16] The Michigan turrets seem substantially heavier in their combination of Weymouth granite and Indiana limestone. Although Yale's Dwight Chapel, already mentioned, also follows the model of King's College Chapel, its divergence is in the opposite direction, as it is markedly more slender in its proportions than the Cambridge work.[17]

The interior of the Ann Arbor Dining Hall totally departs from the model of the Cambridge chapel. The chapel's gorgeous fan-vaulted interior is the superb tour de force of the Tudor king, Henry VII, and the last of the chapel's architects, John Wastell, who completed the work about 1515. The Michigan hall (fig. 92) reflects a mixed heritage. Its open timbered ceiling, constructed of rough-hewn oak hammer-beams, derives from the monastic refectory tradition known at St. Gall, Poblet, and their descendants in English colleges and universities, such as the commons of St. John's College, Cambridge (1511f.). American derivatives are numerous, for example, Harvard's Memorial Hall by Ware and Van Brunt (ca. 1870); Hutchinson Commons at the University of Chicago (1903), where there is a similar traceried clerestory, wainscoting, and a hammer-beam ceiling; Proctor Hall at Princeton, already noted (1913); and a number of others elsewhere, including those of the Rogers buildings at Yale from the 1920s.[18]

Evoking Oxford or Cambridge was an academic commonplace in the 1910s and 1920s. In Chicago about 1900, President Harper urged Hutchinson and Coolidge, prospective donor and architect respectively, to visit Oxford together; from there Hutchinson wrote that he had some men "taking measurements." Later, Chicago's President Burton visited England with a similar mission.[19] Yale's President James Rowland Angell, accompanied by wealthy donor Edward S. Harkness and James Gamble Rogers, discussed at length in the last chapter, evidently had a similar tour in the 1920s; and Carey Thomas, who engaged Cope at Bryn Mawr, is said to have made such a search for models at Oxford during travel in England and to have looked particularly at Oriel and Wadham Colleges.[20] At Princeton, Cram was cate-

gorical about Oxford and Cambridge. They had "the only style that absolutely expressed [the] ideals of an education." Woodrow Wilson had articulated the aim of this associationism: "by the very simple device of building our new buildings in the Tudor Gothic Style we seem to have added to Princeton the age of Oxford and Cambridge; we have added a thousand years to the history of Princeton by merely putting those lines in our buildings which point every man's imagination to the historic traditions of learning in the English-speaking race."[21]

The search for Michigan's models leads repeatedly to England, but the path leads by way of the East Coast universities enumerated here, for Michigan's structures are actually much more closely allied to those of its eastern cousins than to their inspirations in England. The Michigan Dining Hall embraces this Anglo–ivy league tradition more strongly than any of the Law Quad's other buildings, in which the mixing of sources is freer and the eclecticism more strident. The Dining Hall may thus be thought of as reflecting its medieval heritage most clearly. In addition to the points of similarity that link it to the late medieval structures already mentioned, it preserves echoes of earlier medieval refectories in its siting. It is placed at right angles to the ranges of buildings about it so that it intrudes prominently into the space of the court (fig. 2). This is a twelfth-century feature. It follows the innovation among Cistercian houses of thus orienting monastic refectories, as is evident in numerous surviving abbeys, from Fontenay in France to Fountains in England. Earlier refectories had usually been placed parallel to one of the sides of the courtyard, as in the St. Gall plan. Turning the refectory perpendicular to the cloister court allowed the Cistercian monks more room for their growing communities and provided easy access to the refectory at both ends of the structure, either for monks on the garth or court side, usually with a fountain near that entrance, or for service people from the outside world on the side that extended into lay areas of the abbey. In Ann Arbor, there is a hint of this in the driveway that provides a service entrance for the kitchen from State Street (figs. 13, 14). Thus, vestiges of Cistercian monastic planning amazingly survive in the Ann Arbor quadrangle.[22]

The monastic roots of Michigan's Law Quad design are distant, yet they ineluctably underlie the choice of a quadrangular plan for the ensemble. The concept of monasticism was still influential in the thinking of early architects responsible for planning American campuses. Paul Venable Turner has written an excellent analysis of the phenomenon.[23] American Collegiate Gothic architecture in the 1910s and 1920s openly aped the quadrangles of America's English forebears, and these were in turn derived quite directly from monas-

tic cloisters. The rationale for using quadrangle planning—which created distinctly separate architectural spaces, retreated from, indeed excluded, the rest of the campus, nurtured selected fraternal communities, and, most of all, was respectful of rather than indifferent to the courtyard, which was made central rather than interstitial—was clearly stated during the formative phase of the American Collegiate Gothic movement. To Wilson's assertion at Princeton in the 1890s that college studies were ideally ascetic and required a secluded environment to flourish, can be added the words of architectural critics, such as those of the influential Montgomery Schuyler, namely that quadrangles should "promote the expression which the College grounds should take of seclusion and cloistrality."[24] Schuyler's directive, that a college "should be like a cloister," was buttressed by his view that it should also visibly "exclude the *profanus vulgus*."[25] These ideas mirror Henry James's thought, that a college should be "emblemmatic of cloistrality, restriction and exclusion," as well as the theories of Ashton Willard, another critic, who wrote near the turn of the century that "the severe, calm and tranquil idea of the cloister of colleges is built around its quadrangles." Cram summed them all up pithily by saying that such places should be "half college and half monastery."[26] The Law Quad is surely Ann Arbor's most effective architectural expression of this collegiate ideal (fig. 93).

In the twelfth century, the monastery provided a locus for irrevocable commitment to the life of the spirit and a personal mission aimed at the purification of the soul through union with God. In addition to the ritual of the medieval monastic liturgy and prayer, contemplative reading and study were the means to this spiritual goal. Of these, ritual and prayer took place in the church, but reading and study were more properly undertaken in the cloister. The word *cloister* is used here to refer to the open court or garth about which conventual buildings were arranged; these included dorters and refectories for communal sleeping and dining, as well as chapterhouses, scriptoria, and monks' or canons' parlors. Thus, the cloister was usually the physical and communal center of the monastery. Its nature expressed the ambiguity of the cloistered life by melding quasi-social, outdoor activities (such as conversation and communal washing at the fountain), with some of the most private, internal activities of the individual (such as pondering texts while sitting on the benches of its galleries). It was a free space where air, sunshine, warmth, water, and greenery, all opened the spirit. Yet it was also a place of freedom's antithesis, totally enclosed, shut and immured. It was called a prison and a desert in medieval metaphor; it was also called a garden paradise; or, paradoxically, both prison and paradise at once, so that "although

the body is shut in, all doors are open to the spirit." As a place that was inside the inside of a dwelling the cloister fostered introspection; reading and meditation were centered there, especially the medieval form of reading known as the *lectio divina*, which encouraged rumination on such matters as the relationships between the inner and outer aspects of things, and which fostered deep probing of familiar texts. The learning resulting from such activity was liberating for the individual mind even as it bound together the members of the monastic community.

The rhetoric of the Collegiate Gothic movement revived a number of these ideas, as has already been shown (viz., Wilson's argument about asceticism and learning), and was as heavily in debt to this medieval ideological tradition as its art was to Gothic architecture. The rhetoric of cloistrality at the turn of our century included the belief that collegiate "cloisters" would harbor the examined life by providing the quiet and distance from distraction conducive to sustained reflection. In the Harper Library at Chicago is an inscription: "Read not to contradict nor to believe but to weigh and consider." Knowledge might come easily in the classroom, but lingering wisdom requires quiet rumination, made up of weighing and considering, and a special place to foster it. Yet, the goal of cloistrality was more than simple reclusion for the purpose of study. Being cut off from the world or reclusive was not the same as living in community about a courtyard or cloister. In collegiate quadrangles, the functions of the buildings surrounding the courtyard extended the sense of fraternity that was also to bind residents together. In Ann Arbor, the Law Quad ensemble was unusual in including such nonresidential units as libraries, classrooms, seminar spaces, trial courts, publishing and administrative quarters, and assorted offices. Common participation in activities within these academic venues, which varied in function and yet were held together architecturally, was to reinforce commitment to professional goals, of course, but was also to have the effect of confirming membership in the fraternal community of the Michigan Law School.

Cook insisted on this aspect of his venture, envisioning an academy on the Inns of Court model, hence his requirement that members of the bench and bar be resident in the Lawyers Club guest quarters, as discussed above. As these quarters were also to recall the manorial residences of the English landed gentry, and their American heirs, architectural features of manorial and monastic forms were to merge in the plan. Cook expected that the buildings would foster social as well as intellectual interactions among their various residents; the exchanges would enhance student sophistication and stimulate outstanding academic achievements. Members of the Law School

community would embody ideals issuing from both manorial and monastic sources; they would be both gentlemen and scholars.

In sum, it seems clear that Cook intended the fine structures he was underwriting to work synergistically with his grand design for improving legal education at Michigan and the legal profession at large. His choice of late Gothic as the major stylistic vehicle for his aspirations is thus explained by its compatibility with his aims. It was currently in fashion and appropriate for university purposes. It was the style of the Anglophilic work of Cram and Rogers at Princeton and Yale. It brought with it the many associations discussed earlier that contributed to the perceptions about Michigan Cook strove to create. In his drive to develop the emergent Michigan law school, he was obviously aware of the uses of art. The architectural forms he commissioned were considered inspiring and were meant to be powerful in promoting his goals. They were to convey the traditions he sought to associate with his venture and aid in insuring its greatness. He must have expected that as the traditions were recognized, understood, and absorbed by students and by the world at large, the Gothic architectural environment would articulate in monumental form the high ideals he sought for the legal profession.[27]

NOTES

1. See chap. 4, nn. 2, 4–6. For the English Inns of Court buildings, which survive only in part, see Edson Read Sunderland, "The Inns of Court," *Law Quadrangle Notes* 20 (Fall 1975): 13–17; idem, "Some English Prototypes of the Lawyers Club," *The Brief* (Ann Arbor, 1925), pp. 25–29; Grover C. Grismore, "The Lawyers Club," *Michigan Alumnus* 35 (1928): 247–48. Regarding the Inns of Court idea at Yale, see *The New York Herald Tribune*, June 24, 1926.

2. Reuben A. Holden, *Yale, A Pictorial History* (New Haven, 1967), fig. 44, shows an early illustration of Dwight Chapel in its original function as a library. It was designed by Henry Austin in 1842, during the early wave of Gothic Revival architecture on American campuses, and remodeled for use as a chapel in 1931 when a new library was constructed at Yale. Paul Venable Turner, *Campus, An American Planning Tradition* (Cambridge, Mass., 1984), fig. 119.

3. "Cram, Goodhue and Ferguson, Architects," *Architectural Record* 35/1 (1914); Turner, pp. 234–35; see also Montgomery Schuyler, "Architecture of American Colleges, III, Princeton," *Architectural Record* 27 (February, 1910): 129–60; Constance M. Greiff, Mary W. Gibbons, Elizabeth G. Menzies, *Princeton Architecture, A Pictorial History of Town and Campus* (Princeton, 1967), figs. 184–85.

4. MHC 59-7-1, March 11, 1919, and York's confirmation of the usefulness of the Princeton plan in increasing capacity to 250 students, March 13, 1919.

5. *New York World*, MHC 59-7-3, March 5, 1921.

6. See chap. 4, nn. 14 and 25, and chap. 5, nn. 2, 9, 23, and 48–49. Rogers's work on the Yale Law School dates from 1930–31.

7. MHC 59-18, October 5, 13, 18, and 20, 1922; 59-23, *Specifications*, dated March 19, 1923, pp. 48a, 52.

8. Designs for the interior spaces of the Yale and Michigan buildings are also surprisingly similar. For example, the suite plans for the residential quarters of the Ann Arbor Lawyers Club are close to those designed by Rogers for the Harkness dormitories. James Gamble Rogers, "The Memorial Quadrangle and the Harkness Memorial Tower at Yale," *American Architect* 120, no. 2379 (October, 1921): 300 (plan). In some cases, paneled walls with fireplaces appear almost interchangeable with those in Ann Arbor. George Nichols, "The Memorial Quadrangle at Yale University," *Architecture* 44 (October, 1921): 303.

9. MHC, December, 1926 (blueprints), 59-7-10, July 20, 1927, 60-6, September 20, 1927, 59-7-10, November 11, 15, and 16, 1927, 59-7-11, March 13 and 14, 1928, 59-8, March 23, 1928; UMLSA, March 27, 1928.

10. MHC 59-7-5, January 30, 1923.

11. Montgomery Schuyler, "Architecture of American Colleges, V, University of Pennsylvania, Girard, Haverford, Lehigh and Bryn Mawr Colleges," *Architectural Record* 28 (September, 1910): 182–212, especially 195, 208; Ralph A. Cram, "The Works of Cope and Stewardson," *Architectural Record* 21 (November, 1904): 407–38. Another famous Cope and Stewardson example is at Washington University in St. Louis (1900). Turner, p. 223. The Bryn Mawr arch is graced with particularly charming sculptures of owls, which have their Michigan counterparts in the decorative owls of the Dining Hall stringcourse.

12. Christopher Brooke and Roger Highfield, *Oxford and Cambridge* (New York and Cambridge, 1988), figs. 56, 73, 83, 87, and 91. Shute Gatehouse in Devon provides another random example.

13. Peter Kidson, *A History of English Architecture* (New York, 1963), pp. 138–40, figs. 48–49.

14. Both York and Sawyer began their New York careers in the McKim, Mead and White shop. They continued there until 1898, when they formed their partnership and established their own practice. York had been trained at Cornell, Sawyer at Columbia. Illustrations of architectural details from the sourcebooks used by architects of the day and characteristic of this period have been published by Philip G. Knobloch, *Architectural Details from the Early Twentieth Century* (AIA Press: Washington, D.C., 1991). For discussion of earlier Gothic revival pattern books, see Michael McCarty, *The Origins of the Gothic Revival* (New Haven and London, 1987), chap. 1.

15. Robert Willis and John Willis Clark, *The Architectural History of the University of Cambridge and of the College of Cambridge and Eton*, vol. I (Cambridge, 1886; reprint Cambridge, 1988), pp. 368ff. Alexander Jackson Davis had also followed the Cambridge model in his 1838 plan for a Michigan library and chapel building that was never executed. See chap. 1, n. 3 and chap. 4, n. 31.

16. Francis Woodman, *The Architectural History of King's College Chapel* (London, 1986), makes a point about the recent acquisition of material from these quarries.

17. See n. 2. The Michigan and Cambridge buildings have doubtless been com-

pared in countless term papers written by students of architecture at Michigan. In the Bentley library one survives by Terry Pink, who made a number of interesting observations in 1970 about major differences between the buildings, such as the much greater length (284 versus 140 feet) and somewhat greater height (approximately 81 versus 50 feet) of the Cambridge structure.

Regarding the influence of later medievalizing English architects, such as Pugin and Bodley, see Henry R. Hitchcock, *Architecture: Nineteenth and Twentieth Centuries* (Baltimore, 1958), pp. 98–101, 257, and 392–401.

18. Turner, figs. 123, 238; Jean F. Block, *The Uses of Gothic, Planning and Building the Campus of the University of Chicago, 1892–1932* (Chicago, 1983), p. 66. The stereotype is also characteristic of the Inns of Court dining halls. See Sunderland. On the other hand, Alexander Jackson Davis followed the fan vault design of the *interior* of King's College Chapel for his New York University chapel design of 1835. Davies, p. 50, fig. 2.18, pl. 31. See chap. 1, n. 3.

19. The Harper Memorial Library (ca. 1912) best illustrates the result. Block, pp. 67, 157.

20. According to Robert A. M. Stern, *Pride of Place* (Boston and New York, 1986), p. 56, the tour of Angell, Harkness and Rogers, would have taken place between the Harkness and Sterling commissions. *Bryn Mawr College* (Bryn Mawr, 1985), unpaged. Architect W. E. Kapp similarly toured England in the 1920s with the Wilsons when he helped Mrs. Matilda Dodge Wilson plan her baronial residence for Rochester, Michigan. John B. Cameron *Meadow Brook Hall—Tudor Revival Architecture and Decoration* (Rochester, 1979), pp. 3–4.

21. Wilson's comment about Cope's Princeton buildings, which formed a quadrangle and "created 'a little town' unto itself" is also relevant to Cook's goal for the Michigan Law Quad. Turner, p. 227 nn. 36, 38 (quoted from the *Princeton Alumni Weekly*, December 13, 1902, 200).

22. As in monastic cloisters, York had intended that a fountain would be located just outside the Dining Hall entrance, on the court side. This would have been another vestige of traditional thinking in York's design, but the fountain fell away early as Cook trimmed the budget. See chap. 4, n. 12.

23. Turner, chap. 6, pp. 215–47 ("The Monastic Quadrangle and Collegiate Ideals"). This is not to deny that the plans of Roman houses, ancient peristyle courts, forums, and stoas, in their turn, stand behind the quadrangular planning of medieval cloisters. Alfred Frazer, "Modes of European Courtyard Design Before the Medieval Cloister," *Gesta* 12 (1973): 1–12.

24. Turner, pp. 216, 227.

25. Ibid.

26. Ibid., pp. 217, 220, 227, 230. The quadrangles were also often derived from cathedral yards. Turner cites Charles Dickens's visit to Yale in 1842, when he wrote "the various departments are erected in a kind of park or common in the middle of the town, where they are dimly visible among the shadowing trees. . . . The effect is very like that of an old cathedral yard." Ibid., p. 101. Regarding the ideology of medieval monasticism, see Ilene H. Forsyth, "The Monumental Arts of the Roman-

esque Period: Recent Research. The Romanesque Cloister," *The Cloisters: Studies in Honor of the Fiftieth Anniversary* (New York, 1992), pp. 2–25.

27. See also Peter Fergusson's trenchant remarks on Cram and Ruskin in his recent study, "Medieval Architectural Scholarship in America, 1900–1940: Ralph Adams Cram and Kenneth John Conant," *The Architectural Historian in America, Studies in the History of Art*, vol. 35 (Center for the Advanced Study in the Visual Arts, Symposium Papers 19, Washington, D. C., 1990), pp. 127–42.

Afterword: The Interactive Character of Patronage

No doubt many large commissions have depended on sets of circumstances and personalities as individual as those pursued here, and an understanding of them will, in each case, require a special ad hoc research effort. Of the many insights resulting from this study of the Cook Law Quad, a few stand out. It is not possible to deduce a general principle of patronage that would have wide applicability in the history of art. Rather, this case study suggests that patronage is likely to be a very individual matter that depends on continually shifting variables and constantly changing conditions. By chance, good fortune affected the Law School project and critically aided its realization. The decade, between the war and the depression, provided a conjunction of propitious circumstances: the university, under Burton and his successors, was aggressively launching a major building campaign that was to determine campus planning for the indefinite future and was open to Cook's proposal; the Law School was in a nascent state, hoping for a major expansion of its professional program; land—of just the right size, shape, and location—could be accessed; and a group of unusually talented university officials, who were dedicated to stewardship of the project, were willing to work tirelessly in making an appropriate site available as well as to shepherd the project through a maze of deliberations, involving regents, administrators, faculty, townsfolk and taxpayers around the state. Other serendipitous factors were critical to implementation of the project: ample sources of high quality building material were available; skilled craftsmen who had perfected the arts of stone masonry, wrought iron, stained-glass, and fine wood cabinetry could still be found, in contrast to the dearth of them two decades later, and many of them—such as Samuel Yellin, Ricci and Zari, Heinigke and

Smith—were of outstanding ability; the renowned New York architects, York and Sawyer, were at their height and eager to reinterpret the intricacies of Gothic style in Ann Arbor; the donor, Cook, whose retirement allowed ample time for the project, had no children as expectant heirs and had ample funds at the ready; and, finally, the stock market, whence came much of the funding, was burgeoning, not yet aware of its imminent collapse. There were also lucky accidents (such as Cook's discovery of the use of seam-face granite in nearby Manhattan). Few of these conditions obtained in the next decade when a weak economy suppressed monumental building ventures and the ascendancy of Collegiate Gothic architecture along with its ideology in academe gave way to other modes and mind-sets. Thus, the architectural unity of the quadrangle's ensemble of buildings, so prized by the greater Ann Arbor community as noted at the outset of these pages, is revealed here to be the providential, synchronous result of a particular play of circumstances.

Yet it also owes much to the interactive dynamics of the leading personalities under review. Had Hutchins not had such abundant tact, time, and skill with interpersonal relations, or had Burton, Bates, and Smith not managed matters so adroitly, the project might have taken a different course. Had Cook not been centrally and continually involved with the project, and had he not been so doggedly determined to realize his ideals, it would surely have come to a looser end. The pressure he resolutely imposed on York and Sawyer as well as on numerous representatives of the university ensured consistency in his venture and in part explains the homogeneity of the buildings. Absence of that pressure would have allowed other motivations to gain force and would have occasioned a different and no doubt more various outcome. Faculty committees, who were more closely and realistically attuned to the needs of the school, would certainly have made larger contributions to the planning and the architecture would likely have been more heterogeneous. The result would probably have been both less grand and more functional. Although it must be borne in mind that the planning for Hutchins Hall was already well along at the time of Cook's death, a comparison of Hutchins Hall with the earlier buildings (or of the inscriptions selected by faculty committees compared with those composed by Cook) gives some indication of the concentrated and effective force of Cook's personality on the project. Thus while chance often intervened in the decision-making process, the vision Cook had for his "movement" was determinative. Study of his interactions with Hutchins, Bates, and York reveals that he was often swayed by their arguments, sometimes perhaps even maneuvered, so to speak, by them, but he in turn was able to maneuver others, and he succeeded in

maintaining a surprising amount of control to the very end. Interactive personality dynamics were therefore critical to the successful realization of the project.

With regard to the art of the buildings, it is evident that patron Cook was interacting primarily with York and then with Sawyer but that these two architects stood at the head of a team of men who represented a corporate talent. Although the design of the quadrangle's ensemble of buildings seems to have been principally conceived by York and Sawyer as individuals, the work of numerous architects—Fred Benedict, Philip Greene, Louis Ayres, Henry Diamond, George Styles, Ben Moscowitz, Aaron Ziff, and other architects at the York and Sawyer firm—is subsumed in the project and in the remarkably consistent set of drawings issuing from their shop. The decorative work was also handled by teams of artists and artisans, as was the stone carving, masonry, and stained-glass, yet there is coherence in aesthetic effect. We are not surprised then that the work as a whole does not reflect the style of a single artistic personality; rather it reflects the style of a period (the 1920s), the style of a genre of architecture (academic institutions), and the style of a place (Michigan).

This last—that the style should reflect Michigan—is particularly interesting. Those who designed, made, and ornamented the structures had come from afar, most of them from New York, and the medieval metaphors of Collegiate Gothic had also come from elsewhere, not having been known theretofore on the Michigan campus. Within the parameters of the Gothic mode, however, the special situation outlined above fostered the expression of then current Michigan values. As a public, secular institution in the nation's heartland, Michigan's flagship university had maintained a spare rigor in its character. Although pledged to high intellectual, ethical, and moral standards for its students and committed to outstanding quality and impressive curricular richness in its academic offerings, it had preferred plain thinking in its cultural life and in its architectural programs. Just as it was the region's character to do much with little, to husband resources carefully, to avoid waste through unnecessary indulgence, and to shun artifice and display, it was the region's nature to prefer architectural forms that were simple and open, modest but strong. Correspondingly, the university had done without graceful conventions such as decorative plazas or sculpture gardens. Indeed it had little sculpture; it had avoided the long thematic cycles used at peer institutions to tout their histories, and it lacked the monumental statuary found in other campus's "yards" to honor founding fathers, generous benefactors, or illustrious native sons. As a democratic, state institution, the uni-

versity had similarly avoided reference to religion. It had no School of Divinity or department of religion; theological texts were not a special strength of the otherwise splendid library collections; and it rightly had no conspicuous campus chapel (contrary to the custom of East Coast colleges and universities where the chapel was often the capstone of the campus's architectural environment and central in campus activities). When Hutchins, Bates, and Cook discussed some of the amenities proposed for the Law Quad, Michigan predilections for plainness surfaced in their exchanges (Hutchins thought *one* inscription would suffice; Bates said nonupholstered chairs were quite adequate and harped on the dangers of high style; Cook considered the wrought-iron gates and the courtyard fountain excessive; and so on). Cook was clear about the limits of his own willingness to underwrite luxurious ornaments, especially after 1924, when he indicated that he was "not much on cabalistic signs" and that he would have "no gargoyles, lions rampant and such like gewgaws."

It is a final irony that as he strove to bring the Michigan Law School into an international arena, using architectural metaphors that referred to medieval Europe and specifically alluded to Oxford and Cambridge, Cook's Michigan origins nonetheless inhered in the character of his buildings. His conservative nature impressed itself repeatedly on the project. His insistence on restraint, his fear of gaudy ornamentation, his drive for economy, along with his hope for solidity and permanence, his taste for large-scale monumentality and his desire for noble, elevating forms that would instill high ideals, are all seen in the preferences he voiced during the long decade of the venture. The Michigan quadrangle is indebted to Yale and Princeton architecture for many of its buildings' features, but the Michigan style is aesthetically distinctive. Cook's father's injunction that his son maintain the temperate habits that had served him so well up to his seventeenth birthday is reflected in Cook's choices throughout the project and ultimately in the imposing yet austere forms of the architecture. Simply ornamented, and eschewing excess in myriad ways, the quad's rusticated stones offer friendly access to its large, liberating spaces. As the quad's metaphors further Cook's effort to elevate the status of the Law School and of the university through the uses of art, it is consonant with the region's own temperate idealism.

Appendices

Inscriptions

Lawyers Club

1. Over the main State Street entrance to the Lawyers Club:
 THE CHARACTER OF THE LEGAL PROFESSION DEPENDS ON THE CHARACTER OF
 THE LAW SCHOOLS. THE CHARACTER OF THE LAW SCHOOLS FORECASTS THE
 FUTURE OF AMERICA.

2. Over the west entrance passage to the Law Quad, from South University:
 THE SUPREME COURT: PRESERVER OF THE CONSTITUTION; GUARDIAN OF OUR
 LIBERTIES; GREATEST OF ALL TRIBUNALS.

3. Over the east entrance passage to the Law Quad, from South University:
 UPON THE BAR DEPENDS THE CONTINUITY OF CONSTITUTIONAL GOVERNMENT
 AND THE PERPETUITY OF THE REPUBLIC ITSELF.

4. Over the entrance to the east passage, from the courtyard side:
 THE CONSTITUTION; STEEL FRAME OF THE NATIONAL FABRIC; WITHOUT IT THE
 STRUCTURE WOULD FALL INTO RUINS.

5. Over the entrance to the Dining Hall from the courtyard:
 FREE INSTITUTIONS, PERSONAL LIBERTY.

6. Over the entrance to the central passageway (both sides):
 1924

7. At the interior entrance to the lounge of the Lawyers Club:
 THE LAWYERS CLUB. FOUNDED APRIL 1922 BY WILLIAM W. COOK. AB 1880 LLB 1882.
 OF THE AMERICAN BAR.

8. Over the interior entrance of the Dining Hall:
 ARTES. SCIENTIA. VERITAS

The John P. Cook Dormitory Building

At the exterior bay, on Tappan Avenue:
JOHN P. COOK, INTRINSICALLY A GREAT MAN, PROMINENT IN THE TERRITORY, AND
LATER IN THE STATE.

The Legal Research Building

1. Over the north entrance, north doorway (exterior right):
 LEARNED AND CULTURED LAWYERS ARE SAFEGUARDS OF THE REPUBLIC
 (exterior left):
 LAW EMBODIES THE WISDOM OF THE AGES—PROGRESS COMES SLOWLY

2. Within the reading room, over the interior entrance, right:
 A LITTLE LEARNING IS A DANGEROUS THING. DRINK DEEP OR TASTE NOT.
 over the interior entrance, left:
 JURISPRUDENCE IS A MILESTONE MARKING THE PROGRESS OF A NATION.

3. Within the entrance vestibule (these four vestibule inscriptions were se-
 lected after William Cook's death):
 (on the west side, left):
 AS THE LAWS ARE ABOVE MAGISTRATES SO ARE THE MAGISTRATES ABOVE THE
 PEOPLE. AND IT MAY TRULY BE SAID THAT THE MAGISTRATE IS A SPEAKING LAW
 AND THE LAW IS A SILENT MAGISTRATE. CICERO.
 (on the west side, right):
 IN EFFECT TO FOLLOW NOT TO FORCE THE PUBLIC INCLINATION, TO GIVE A DI-
 RECTION A FORM, A TECHNICAL DRESS, AND A SPECIFIC SANCTION TO THE GEN-
 ERAL SENSE OF COMMUNITY IS THE TRUE END OF LEGISLATION. BURKE.
 (on the east side, left):
 JUSTICE AND POWER MUST BE BROUGHT TOGETHER SO THAT WHATEVER IS JUST
 MAY BE POWERFUL AND WHATEVER IS POWERFUL MAY BE JUST. PASCAL.
 (east side, right):
 LAWS ARE THE VERY BULWARK OF LIBERALITY. THEY DEFINE EVERY MAN'S RIGHTS
 AND DEFEND THE INDIVIDUAL LIBERTIES OF ALL MEN. HOLLAND.

4. On the south wall of the reading room (this inscription was commissioned
 by the university following Cook's death):
 THE BUILDINGS FORMING THIS LAW SCHOOL QUADRANGLE TOGETHER WITH THE
 SUPPORTING ENDOWMENT ARE THE GIFT OF WILLIAM W. COOK OF THE CLASS
 OF 1882. TO HIS MEMORY THE UNIVERSITY ERECTS THIS TABLET. 1930.

5. Over the north entrance:

 THE WILLIAM W. COOK LEGAL RESEARCH BUILDING

Hutchins Hall

1. Exterior:

 AUDITE ALTERAM PARTEM; LIT[T]ERAE SCRIPTAE MANE[N]T

 JUS E[S]T ARS BON[I] ET AEQUI

 HUTCHINS HALL. THE UNIVERSITY OF MICHIGAN LAW SCHOOL.

 ANNO DOMINI. MCMXXXII. WWC 1880 LLB [18]82 HBH 1871

 LLD 1920

 HUTCHINS HALL 1932

 THE LAW REVIEW 1932

2. Inside the entrance to the cloister walkways:

 HONESTE VIVERE ALTERUM NON LAEDERE SUUM CIRQUE TRIBUERE

 FIAT JUSTITIA RUAT COELUM

 THE LIFE OF THE LAW HAS NOT BEEN LOGIC, IT HAS BEEN EXPERIENCE.

Subjects in Stained Glass

Dining Hall

East window:
 Upper range (left to right):
 The Scales
 The Scorpion
 The Centaur
 The University of Michigan seal (now the State of Michigan)
 The Goat
 The Water Bearer
 The Fishes
 Lower range:
 Wisdom
 Commerce
 Wheel of Fortune
 The Ship of State
 Peace
 The State of Michigan seal
 Hope
West window:
 Upper range:
 The Ram
 The Bull
 The Twins
 The State of Michigan seal (now the University of Michigan)
 The Crab
 The Lion
 The Virgin

Lower range:
 Justice
 The United States of America seal
 Knowledge
 The University of Michigan seal
 Time
 Tree of Knowledge
 Prosperity

The John P. Cook Dormitory Building—The John P. Cook Memorial Room

Branches of the Law:
 Religious Law (holy books)
 Moral Law (inscribed stone tablets)
 Ceremonial Law (flaming altar)
 Arms of the State of Michigan seal, circumscribed by "John Potter Cook 1812–1884"
 Natural Law (helmet and shield)
 Common Law (wig, gavel, and gown)
 International Law (international flags and fasces)
 Civil Law (sword and balance)
 Statute Law (scroll and sceptre)

Legal Research Building

Arms and shields of universities and colleges of the world (for a complete list, see the chart by Heinigke and Smith, fig. 32, and in the library reading room).

East window:
 Upper range (left to right):
 Oxford-Jesus
 Oxford-Christ Church
 Oxford-Queens
 University of Michigan
 Oxford-Oriel
 Oxford-Brasenose
 Oxford-Balliol
 Lower range:
 New York University

Columbia
Yale
State of Michigan
Princeton
Harvard
Cornell
West window:
 Upper range:
 Cambridge-Trinity
 Cambridge-Corpus Christi
 Cambridge-Christ's
 University of Michigan
 Cambridge-Queens'
 Cambridge-Pembroke
 Cambridge-King's
 Lower range:
 Iowa
 Northwestern
 Indiana
 University of Michigan
 Colorado
 Chicago
 Washington

Hutchins Hall

Windows of the cloister walkways:
 South walk:
 Qui tacet consentire vihetur.
 Contract
 Perjury
 Ignorantia legis neminem excusat.
 Divorce
 Inheritance
 Leguum et bonum est lex legum.
 Assault
 Arson
 Ubi jus, ibi remedium.
 Extortion

 Marine Law

East walk:

 Ex pactos illicito non oritur actio.

 Conspiracy

 Burglary

 Quod nullius est, est domini regis.

 Petty larceny

 Receiving of stolen goods

 Necessitas publica major est quam privata.

 Contracts

 Coercion

 Interest rei publicae ut sit finis litium.

 Disguise

 Forgery

 Communis errou? facit jus.

 Gambling

 Barratry

 Delegatus non potest delegare.

 Accessory

 Mayhem

 Sic utere tuo ut alienum non laedas.

 Manslaughter

 Nuisance

North walk:

 Cessante ratione legis, cessa ipsa lex.

 Honor

 Murder

 Qui eadem est ratio, eadem est lex.

 Anarchy

 Military

 Lex nil foustra facit.

 Robbery

 Larceny

 Aequitas sequitur legem.

 Patent law

 Bribery

 Falsus in uno, falsus in omnibus.

 Pure food

 Fraud

Damnum sine injuria esse potest.
 Malicious mischief
 Bankruptcy
Audi alteram partem.
 St. Matthew 5:21
 Traffic
East stairway:
 south: Injuria non excusat injuriam.
 north: Diditas est justitiae mater.

Sources of Illustrations

Frontispiece. Dining Hall, University of Michigan Law Quad. (Photo: MHC, Ivory Photo.)

Fig. 1. Cloister and courtyard, University of Michigan Law Quad. (Photo: UMIS.)

Fig. 2. Air view, University of Michigan Law Quad. (Photo: MHC, Ivory Photo.)

Fig. 3. Disposition of the Cook Law Quad buildings, University of Michigan. (Photo: drawing by Rebecca Price-Wilkin, UMPS.)

Fig. 4. The Legal Research Building and the adjacent underground library addition by Gunnar Birkerts, University of Michigan Law Quad. (Photo: *Architectural Record* [March, 1982]. Copyright [1982] by McGraw Hill, Inc. All rights reserved. Reproduced with the permission of the publisher.)

Fig. 5. William Wilson Cook, ca. 1882. (Photo: MHC.)

Fig. 6. Bronze bust of William Wilson Cook, made after his death in 1930 by Georg J. Lober. (Photo: UMIS.)

Fig. 7. The Cook family home at 139 Hillsdale Street, Hillsdale, Michigan. (Photo: author.)

Fig. 8. Plan of Ann Arbor, ca. 1914. (Photo: MHC.)

Fig. 9. Plan of Ann Arbor, ca. 1921. (Photo: MHC.)

Fig. 10. Diagram of plots for the Law School. (Photo: MHC.)

Fig. 11. Buildings of the first campaign, view from the Union, ca. 1924. (Photo: after *Architecture* [July, 1925]. Copyright 1925 by Scribner's Sons [Macmillan]. Reproduced with the permission of the publisher.)

Fig. 12. The Lawyers Club, from the intersection of South University and State Streets, presentation drawing by York and Sawyer. (Photo: MHC.)

Fig. 13. Plan for the Law Quad plot, blueprint by York and Sawyer, ca. 1924. (Photo: MHC.)

Fig. 14. Plot plan, Law Quad, ca. 1981. (Photo: MHC.)

Fig. 15. Law Quad, view across the courtyard. (Photo: Patrick J. Young and Jeri Hollister.)

Fig. 16. Lawyers Club, view from State Street. (Photo: Adelaide Adams.)

Fig. 17. John P. Cook Dormitory Building, view from Tappan Avenue. (Photo: Patrick J. Young and Jeri Hollister.)

Fig. 18. Gateway to the Harkness Memorial Quadrangle, High Street, Yale University. (Photo: Patti McConville, The Image Bank.)

Fig. 19. The towered gateway, main entrance to the Law Quad, presentation drawing by York and Sawyer. (Photo: MHC.)

Fig. 20. Henry Ives Cobb's plan for the University of Chicago, ca. 1893. (Photo: after Jean F. Block, *The Uses of Gothic: Planning and Building the Campus of the University of Chicago 1892–1932* [Copyright, University of Chicago Press, 1983]. Reproduced with the permission of the publisher.)

Fig. 21. The perimeter of the Harkness Memorial Quadrangle, Yale University. (Photo: author.)

Fig. 22. Construction of the Law Quad, October 12, 1923. (Photo: MHC.)

Fig. 23. Construction of the Law Quad, view from Tappan Street, April 24, 1924. (Photo: MHC.)

Fig. 24. Construction of the Law Quad, view from the courtyard, July 15, 1924. (Photo: MHC.)

Fig. 25. Construction of the cloister arcade, January 23, 1924. (Photo: MHC.)

Fig. 26. Law Quad, stonework and entries on the courtyard. (Photo: Patrick J. Young and Jeri Hollister.)

Fig. 27. Legal Research Building (library), view of the courtyard facade, from the north. (Photo: MHC, Ivory Photo.)

Fig. 28. Dining Hall, stained-glass lancets of the east window. (Photo: UMIS.)

Fig. 29. Diagram of the plan for the stained-glass windows of the Dining Hall, York and Sawyer. (Photo: UMESA.)

Fig. 30. Cartoons for the stained-glass windows of the Dining Hall, signs of the zodiac. (Photo: UMESA.)

Fig. 31. Cartoons for the stained-glass windows of the Dining Hall, seals of the University and the state of Michigan. (Photo: UMESA.)

Fig. 32. Chart of stained-glass windows for the Legal Research Building, by Heinigke and Smith, 1930. (Photo: UMLSA.)

Fig. 33. Legal Research Building (library), interior of the reading room, stained-glass window on the west. (Photo: UMIS.)

Fig. 34. Hutchins Hall, north entrance from the courtyard, York and Sawyer drawing. (Photo: UMESA.)

Fig. 35. Hutchins Hall, north entrance from the courtyard. (Photo: Patrick J. Young and Jeri Hollister.)

Fig. 36. Hutchins Hall, glazed gallery of the cloister. (Photo: UMIS.)

Fig. 37. Hutchins Hall, window of the cloister: "Mayhem." (Photo: Patrick J. Young and Jeri Hollister.)

Fig. 38. Hutchins Hall, window of the cloister: "Malicious Mischief." (Photo: Patrick J. Young and Jeri Hollister.)

Fig. 39. Hutchins Hall, cartoon for window of the cloister: Matthew 5:21 ("Murder"). (Photo: MHC.)

Fig. 40. Hutchins Hall, window of the cloister: "Petty Larceny." (Photo: Patrick J. Young and Jeri Hollister.)

Fig. 41. Hutchins Hall, window of the cloister: "Barratry." (Photo: Patrick J. Young and Jeri Hollister.)

Fig. 42. Sterling Law Building, Yale University, stained-glass windows, barristers. (Photo: Patrick J. Young and Jeri Hollister.)

Fig. 43. Dining Hall, Law Quad, structure and carving of the ceiling beams, York and Sawyer drawing. (Photo: UMESA.)

Fig. 44. East entrance to the Law Quad. (Photo: author.)

Fig. 45. Elevation of the east entrance passage, York and Sawyer drawing. (Photo: UMESA.)

Fig. 46. Sculptured corbel for the east passage, York and Sawyer drawing. (Photo: UMESA.)

Fig. 47. Corbel (E 6) representing Fall (man with grape harvest), east passage. (Photo: Patrick J. Young and Jeri Hollister.)

Fig. 48. Corbel (E 12) representing Winter (old man with a scythe), east passage. (Photo: Patrick J. Young and Jeri Hollister.)

Fig. 49. Corbel (E 11) representing Spring (youth with flowers), east passage. (Photo: Patrick J. Young and Jeri Hollister.)

Fig. 50. Corbel (E 5) representing Summer (wheat harvester), east passage. (Photo: Patrick J. Young and Jeri Hollister.)

Fig. 51. Plan showing location of carved corbels in the east, central, and west entranceways to the Law Quad. (Photo: drawing by Rebecca Price-Wilkin, UMPS.)

Fig. 52. Corbel (E 8) representing a football player (Fall), east passage. (Photo: Patrick J. Young and Jeri Hollister.)

Fig. 53. Corbel with the helmeted head of a football player, Princeton University. (Photo: after Gambee, *Princeton*.)

Fig. 54. Corbel (E 10) representing an ice hockey player (Winter), east passage. (Photo: Patrick J. Young and Jeri Hollister.)

Fig. 55. Corbel (E 9) representing a baseball player (Spring), east passage. (Photo: Patrick J. Young and Jeri Hollister.)

Fig. 56. Corbel (E 7) representing a tennis player (Summer), east passage. (Photo: Patrick J. Young and Jeri Hollister.)

Fig. 57. Corbel (E 4) representing an engineer, east passage. (Photo: Patrick J. Young and Jeri Hollister.)

Fig. 58. Corbel (E 3) representing an architect, east passage. (Photo: Patrick J. Young and Jeri Hollister.)

Fig. 59. Corbel (E 2) representing an artist, east passage. (Photo: Patrick J. Young and Jeri Hollister.)

Fig. 60. Corbel (E 1) representing a jurist, east passage. (Photo: Patrick J. Young and Jeri Hollister.)

Fig. 61. Corbel (W 2) representing a crusading warrior (military science?), west passage. (Photo: Patrick J. Young and Jeri Hollister.)

Fig. 62. Corbel (W 4) representing medical science, west passage. (Photo: Patrick J. Young and Jeri Hollister.)

Fig. 63. Corbel (W 3) representing commerce or economics ("Archimedes"), west passage. (Photo: Patrick J. Young and Jeri Hollister.)

Fig. 64. Corbel (W 1) representing an explorer or astronomy, west passage. (Photo: Patrick J. Young and Jeri Hollister.)

Fig. 65. Towered gateway, main entrance to the Law Quad, central passage. (Photo: Gerald Carr.)

Fig. 66. Entrance to the central passage with the large corbels. (Photo: Adelaide Adams.)

Fig. 67. Section through the first bay of the tower, central passage, York and Sawyer drawing. (Photo: UMESA.)

Fig. 68. Carved corbel (C 2) representing President Harry Burns Hutchins, central passage. (Photo: Patrick J. Young and Jeri Hollister.)

Fig. 69. Photo portrait of President Hutchins. (Photo: MHC.)

Fig. 70. Sculptor's model for the Hutchins corbel. (Photo: MHC.)

Fig. 71. Carved corbel (C 4) representing President James Burrill Angell, central passage. (Photo: Patrick J. Young and Jeri Hollister.)

Fig. 72. Photo portrait of President Angell. (Photo: MHC.)

Fig. 73. Carved corbel (C 6) representing President Marion Leroy Burton, central passage. (Photo: Patrick J. Young and Jeri Hollister.)

Fig. 74. Photo portrait of President Burton. (Photo: MHC.)

Fig. 75. Sculptors' models for three corbels (C 1, C 6, and C 5), representing Secretary Shirley Smith (43), President Burton (40), and Professor Jerome Knowlton (39). (Photo: MHC.)

Fig. 76. Photo portrait of Secretary Smith. (Photo: MHC.)

Fig. 77. Photo portrait of Professor Knowlton. (Photo: MHC.)

Fig. 78. Sculptor's model for corbel (C 3) of Dean Henry Moore Bates. (Photo: MHC.)

Fig. 79. Photo portrait of Dean Bates. (Photo: MHC.)

Fig. 80. Carved corbel (C 5) representing President Erastus O. Haven, central passage. (Photo: Patrick J. Young and Jeri Hollister.)

Fig. 81. Portrait of President Haven. (Photo: MHC.)

Fig. 82. Carved corbel (C 1) representing President Henry Simmons Frieze, central passage. (Photo: Patrick J. Young and Jeri Hollister.)

Fig. 83. Portrait of President Frieze. (Photo: MHC.)

Fig. 84. Carved corbel (C 3) representing President Henry Philip Tappan, central passage. (Photo: Patrick J. Young and Jeri Hollister.)

Fig. 85. Portrait of President Tappan. (Photo: MHC.)

Fig. 86. Hutchins Hall, inscription over north entrance to the glazed cloister gallery. (Photo: Patrick J. Young and Jeri Hollister.)

Fig. 87. Sterling Law Building, Yale University, inscription over the entrance to the building, from the courtyard. (Photo: Patrick J. Young and Jeri Hollister.)

Fig. 88. Blair Arch, Princeton University. (Photo: author.)

Fig. 89. Rockefeller Hall, Bryn Mawr College. (Photo: author.)

Fig. 90. Cambridge, King's College Chapel. (Photo: Gerald Carr.)

Fig. 91. Dining Hall, University of Michigan Law Quad, turret. (Photo: UMIS.)

Fig. 92. Dining Hall, University of Michigan Law Quad, interior. (Photo: Patrick J. Young and Jeri Hollister.)

Fig. 93. Dining Hall, University of Michigan Law Quad, from the arcade of the courtyard. (Photo: Gerald Carr.)

Index

Plates

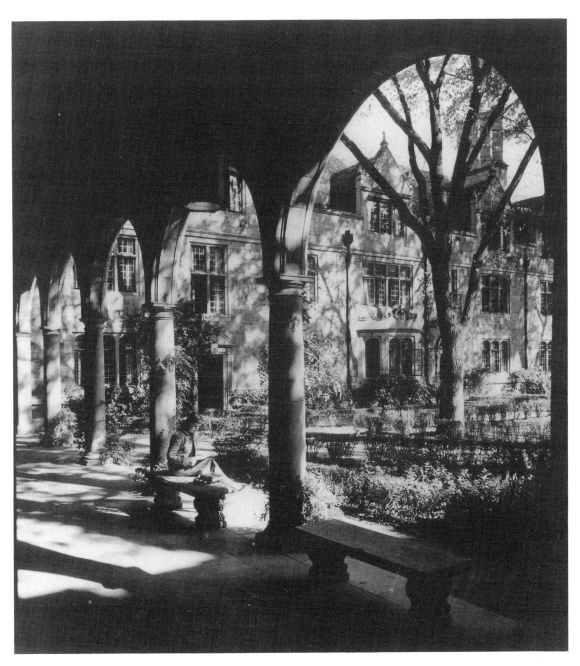

Fig. 1. *Cloister and courtyard, University of Michigan Law Quad*

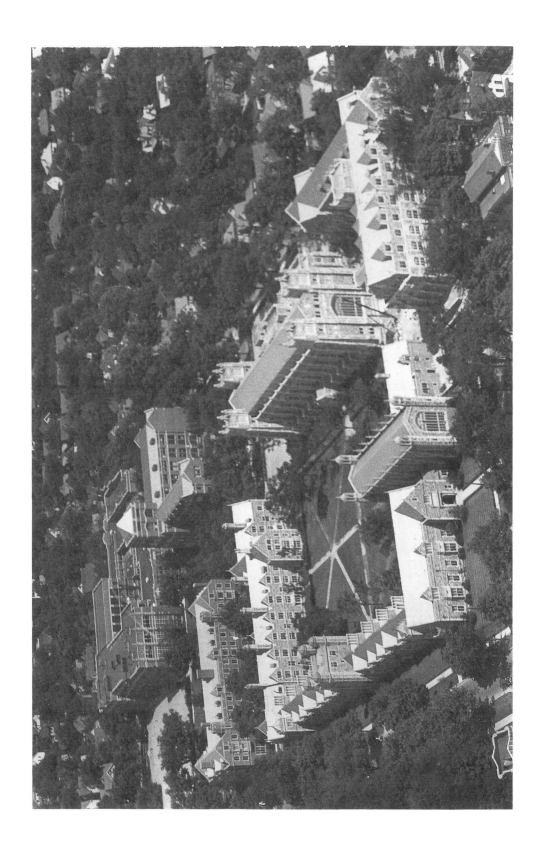

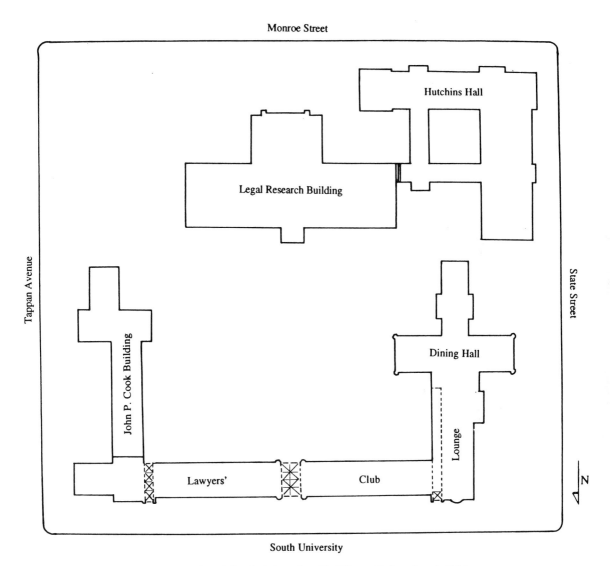

Monroe Street

Hutchins Hall

Legal Research Building

Tappan Avenue

State Street

John P. Cook Building

Dining Hall

Lounge

Lawyers' Club

N

South University

Fig. 3. *Disposition of the Cook Law Quad buildings, University of Michigan*

Fig. 2. *Air view, University of Michigan Law Quad*

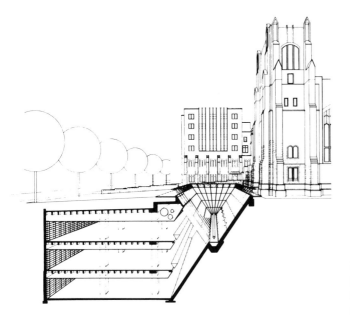

Fig. 4. *The Legal Research Building and the adjacent underground library addition by Gunnar Birkerts, University of Michigan Law Quad*

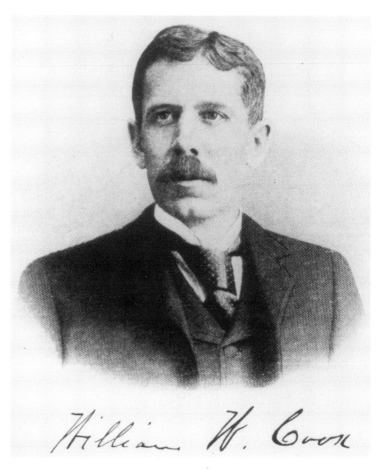

Fig. 5. *William Wilson Cook, ca. 1882*

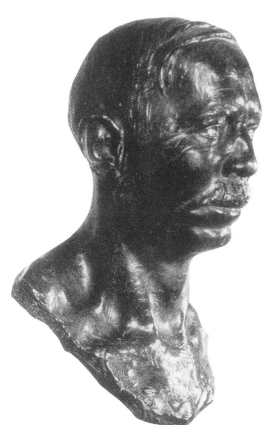

Fig. 6. *Bronze bust of William Wilson Cook, made after his death in 1930 by Georg J. Lober*

Fig. 7. *The Cook family home at 139 Hillsdale Street, Hillsdale, Michigan*

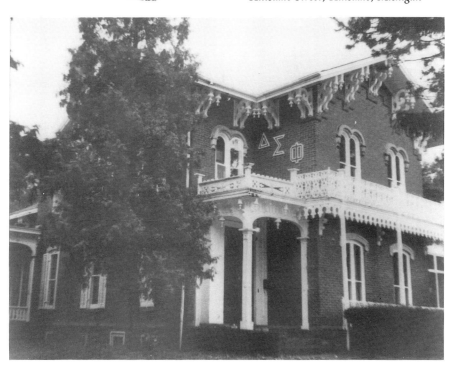

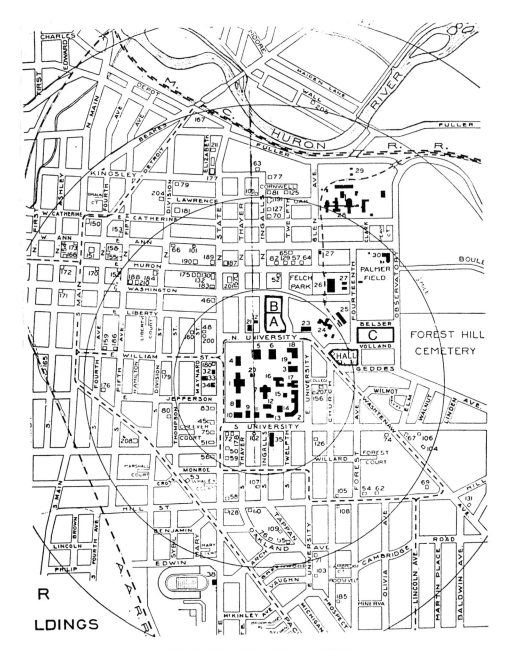

Fig. 8. *Plan of Ann Arbor, ca. 1914*

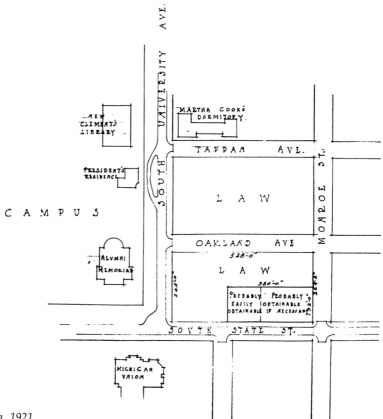

Fig. 9. *Plan of Ann Arbor, ca. 1921*

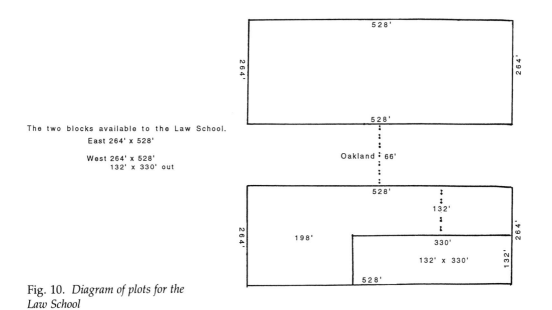

The two blocks available to the Law School.
 East 264' x 528'

 West 264' x 528'
 132' x 330' out

Fig. 10. *Diagram of plots for the Law School*

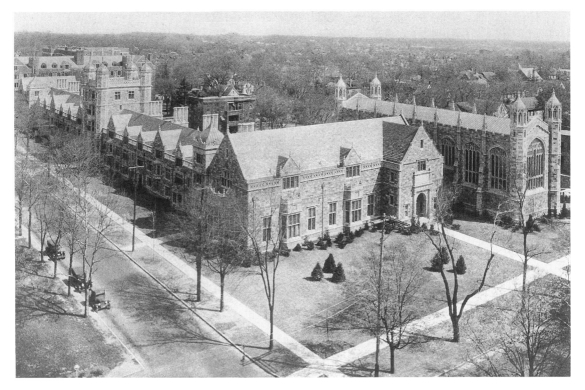

Fig. 11. *Buildings of the first campaign, view from the Union, ca. 1924*

Fig. 12. *The Lawyers Club, from the intersection of South University and State Streets, presentation drawing by York and Sawyer*

Fig. 13. *Plan for the Law Quad plot, blueprint by York and Sawyer, ca. 1924*

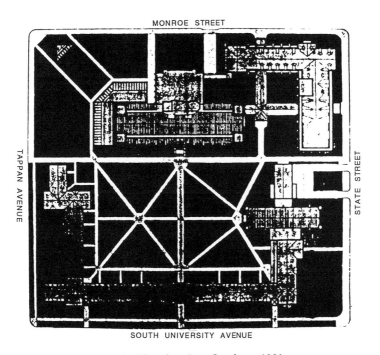

Fig. 14. *Plot plan, Law Quad, ca. 1981*

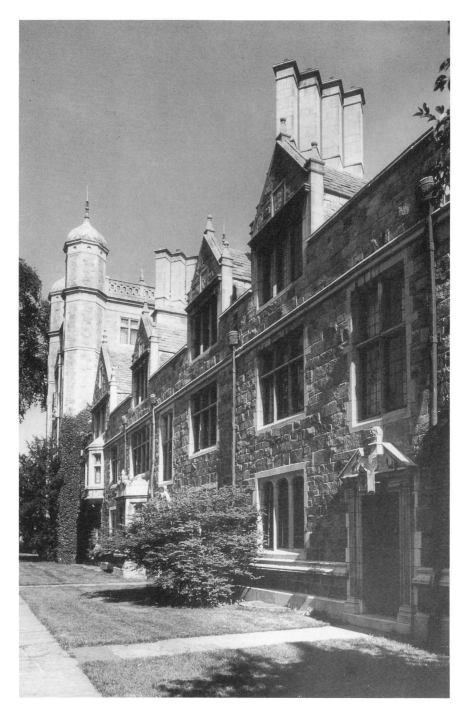

Fig. 15. *Law Quad, view across the courtyard*

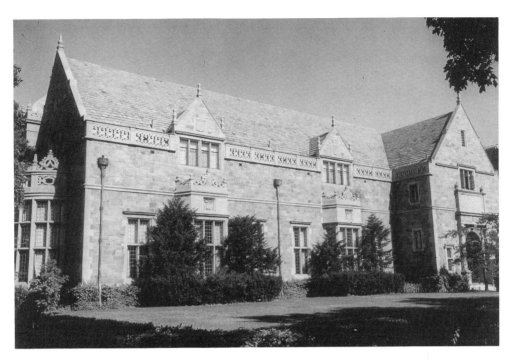

Fig. 16. *Lawyers Club, view from State Street*

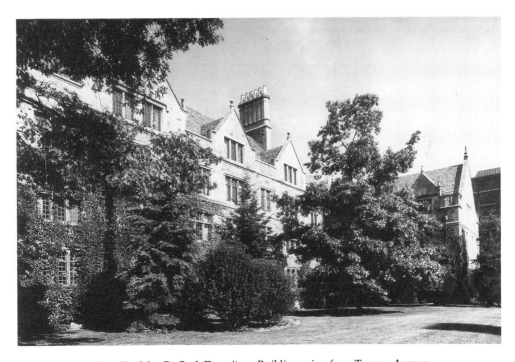

Fig. 17. *John P. Cook Dormitory Building, view from Tappan Avenue*

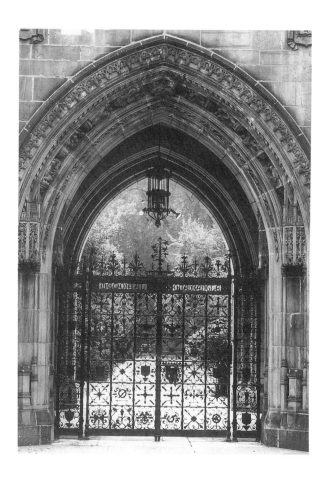

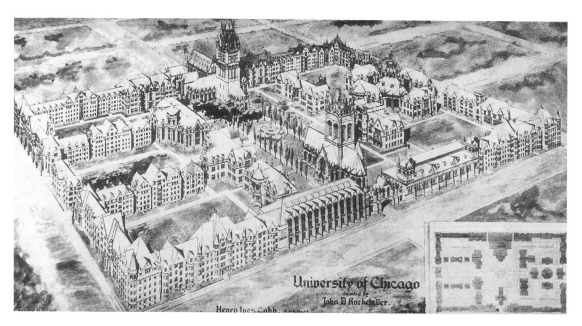

University of Chicago
founded by
John D Rockefeller.

Henry Ives Cobb, Architect

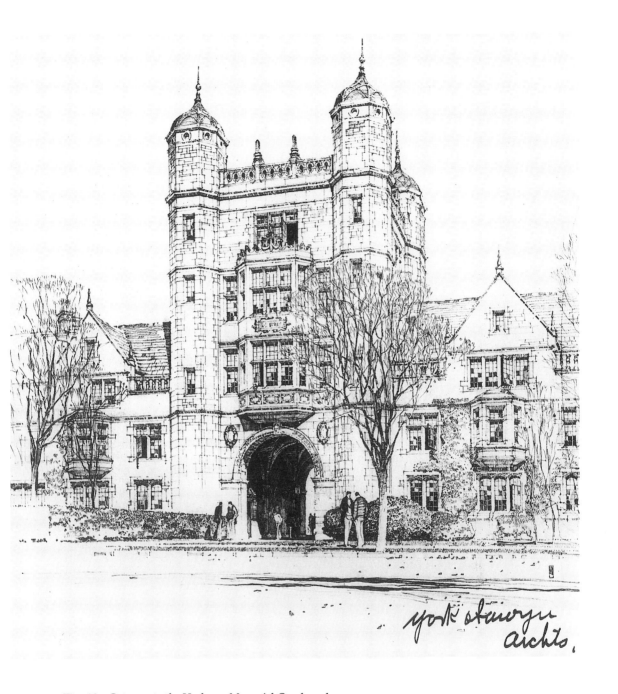

Fig. 18. *Gateway to the Harkness Memorial Quadrangle,*
High Street, Yale University (upper left)

Fig. 19. *The towered gateway, main entrance to the Law Quad,*
presentation drawing by York and Sawyer (above)

Fig. 20. *Henry Ives Cobb's plan for the University of Chicago, ca. 1893 (left)*

Fig. 21. *The perimeter of the Harkness Memorial Quadrangle, Yale University*

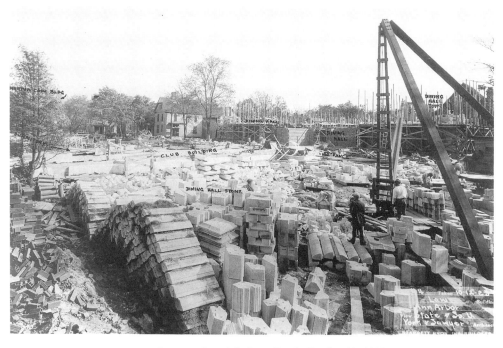

Fig. 22. *Construction of the Law Quad, October 12, 1923*

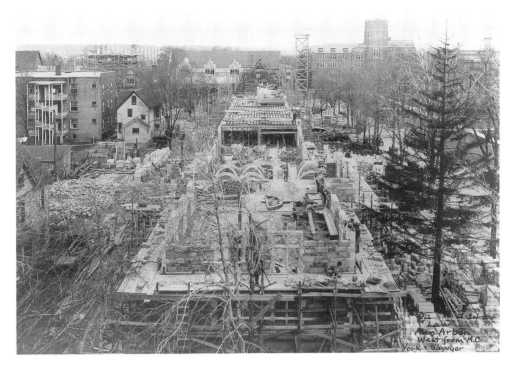

Fig. 23. *Construction of the Law Quad, view from Tappan Street, April 24, 1924*

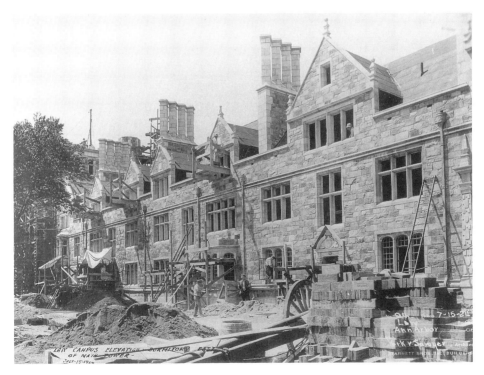

Fig. 24. *Construction of the Law Quad, view from the courtyard, July 15, 1924*

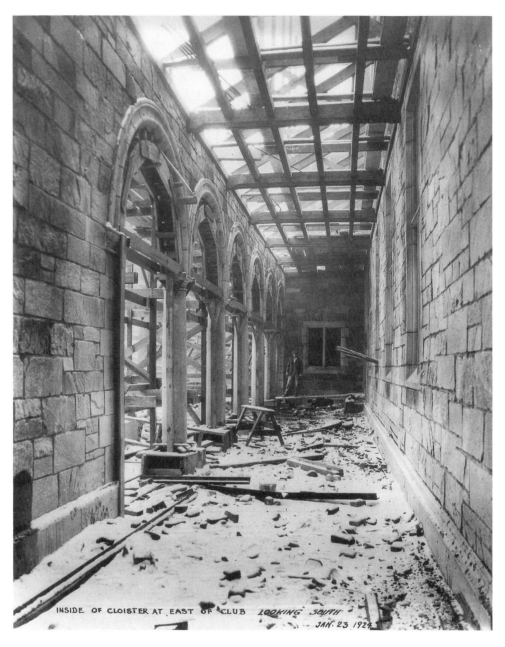

INSIDE OF CLOISTER AT EAST OF CLUB *LOOKING SOUTH* JAN. 23 1924

Fig. 25. *Construction of the cloister arcade, January 23, 1924*

Fig. 26. *Law Quad, stonework and entries on the courtyard*

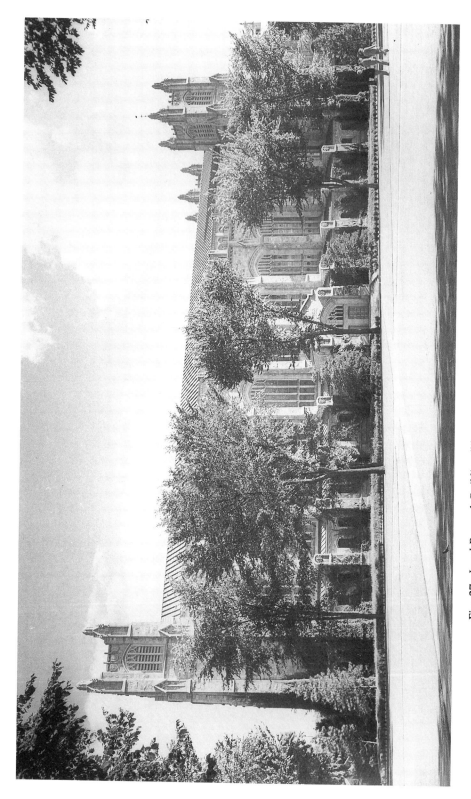

Fig. 27. *Legal Research Building (library), view of the courtyard facade, from the north*

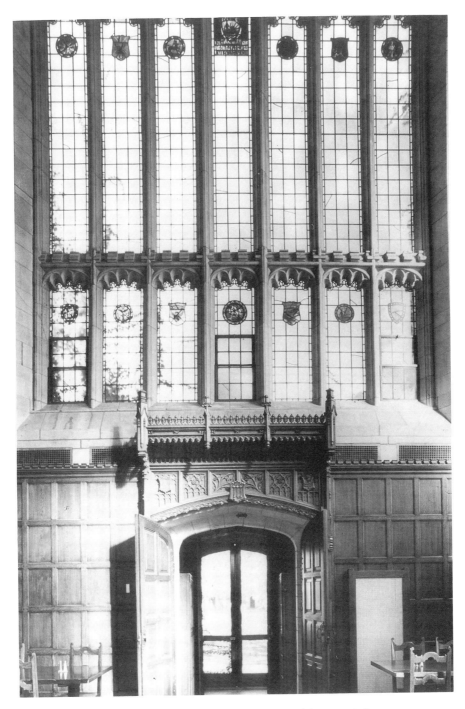

Fig. 28. *Dining Hall, stained-glass lancets of the east window*

Fig. 29. *Diagram of the plan for the stained-glass windows of the Dining Hall, York and Sawyer*

Fig. 30. *Cartoons for the stained-glass windows of the Dining Hall, signs of the zodiac*

Fig. 31. *Cartoons for the stained-glass windows of the Dining Hall, seals of the University and the state of Michigan*

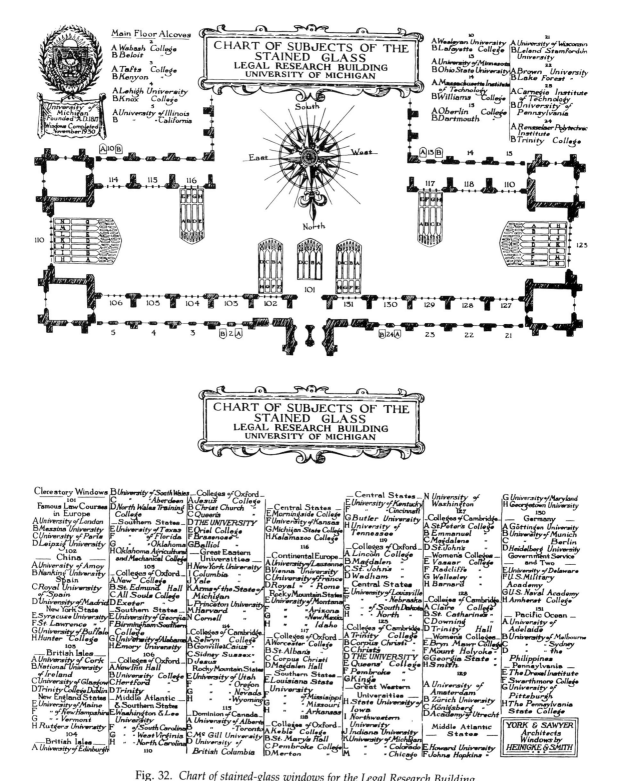

Fig. 32. *Chart of stained-glass windows for the Legal Research Building, by Heinigke and Smith, 1930*

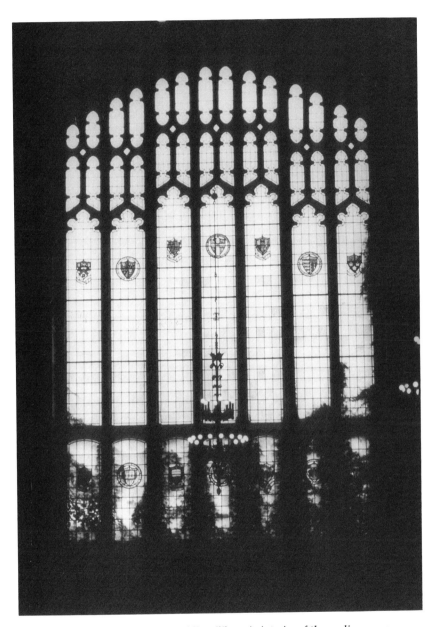

Fig. 33. *Legal Research Building (library), interior of the reading room, stained-glass window on the west*

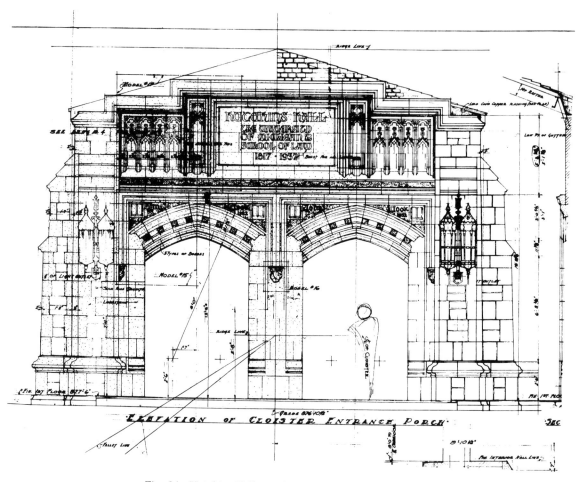

Fig. 34. *Hutchins Hall, north entrance from the courtyard,*
York and Sawyer drawing

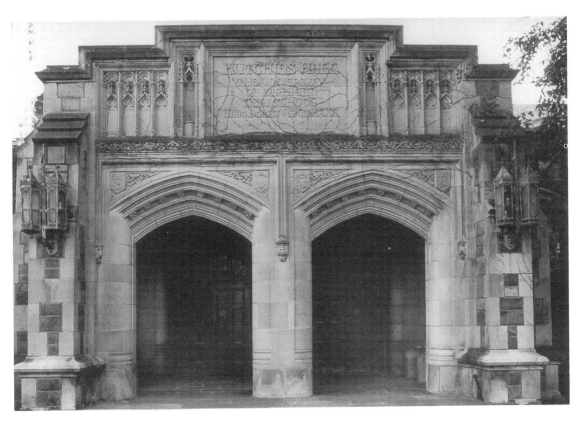

Fig. 35. *Hutchins Hall, north entrance from the courtyard*

Fig. 36. *Hutchins Hall, glazed gallery of the cloister*

Fig. 37. *Hutchins Hall, window of the cloister: "Mayhem"*

Fig. 38. *Hutchins Hall, window of the cloister: "Malicious Mischief"*

Fig. 39. *Hutchins Hall, cartoon for window of the cloister: Matthew 5:21 ("Murder")*

Fig. 40. *Hutchins Hall, window of the cloister: "Petty Larceny"*

Fig. 41. *Hutchins Hall, window of the cloister: "Barratry"*

Fig. 42. *Sterling Law Building, Yale University, stained-glass windows, barristers*

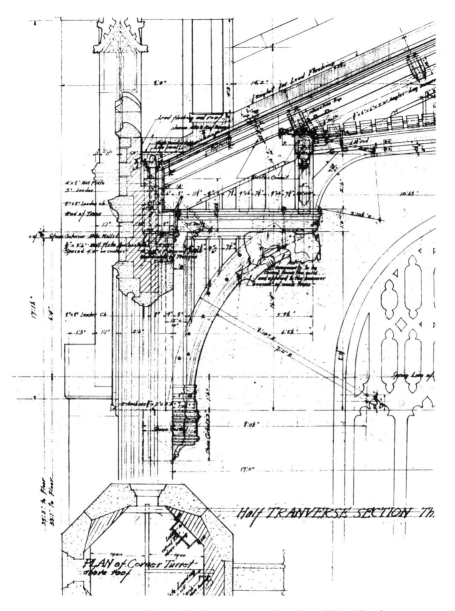

Fig. 43. Dining Hall, Law Quad, structure and carving of the ceiling beams, York and Sawyer drawing

Fig. 44. *East entrance to the Law Quad*

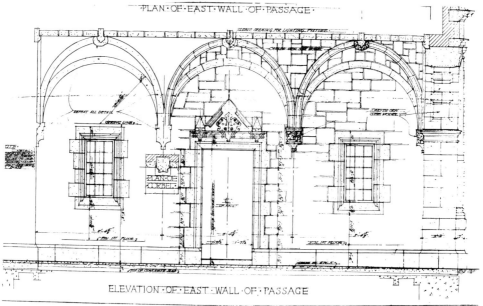

Fig. 45. *Elevation of the east entrance passage, York and Sawyer drawing*

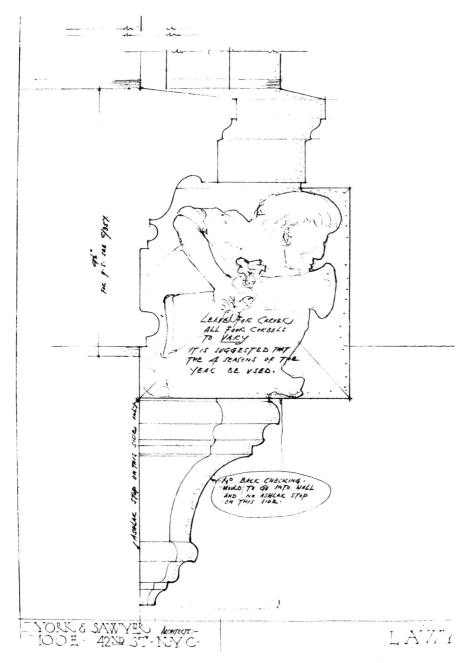

Fig. 46. *Sculptured corbel for the east passage, York and Sawyer drawing*

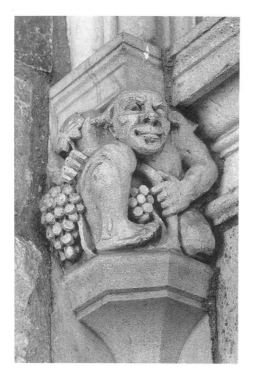

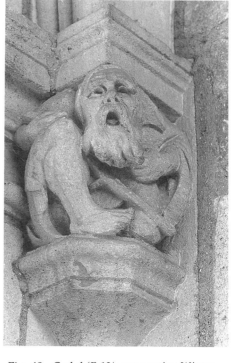

Fig. 47. *Corbel (E 6) representing Fall (man with grape harvest), east passage*

Fig. 48. *Corbel (E 12) representing Winter (old man with a scythe), east passage*

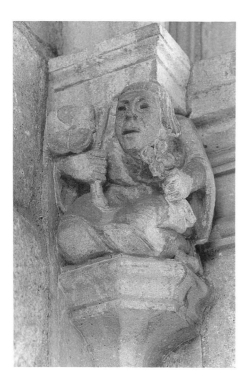

Fig. 49. *Corbel (E 11) representing Spring (youth with flowers), east passage*

Fig. 50. *Corbel (E 5) representing Summer (wheat harvester), east passage*

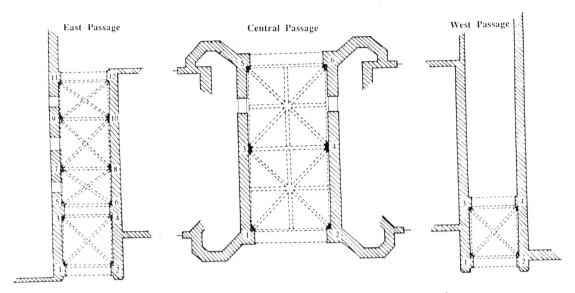

Fig. 51. *Plan showing location of carved corbels in the east, central, and west entranceways to the Law Quad*

Fig. 52. *Corbel (E 8) representing a football player (Fall), east passage*

Fig. 53. *Corbel with the helmeted head of a football player, Princeton University*

Fig. 54. *Corbel (E 10) representing an ice hockey player (Winter), east passage*

Fig. 55. *Corbel (E 9) representing a baseball player (Spring), east passage*

Fig. 56. *Corbel (E 7) representing a tennis player (Summer), east passage*

Fig. 57. *Corbel (E 4) representing an engineer, east passage*

Fig. 58. *Corbel (E 3) representing an architect, east passage*

Fig. 59. *Corbel (E 2) representing an artist, east passage*

Fig. 60. *Corbel (E 1) representing a jurist, east passage*

Fig. 61. *Corbel (W 2) representing a crusading warrior (military science?), west passage*

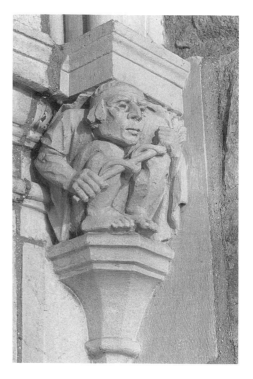

Fig. 62. *Corbel (W 4) representing medical science, west passage*

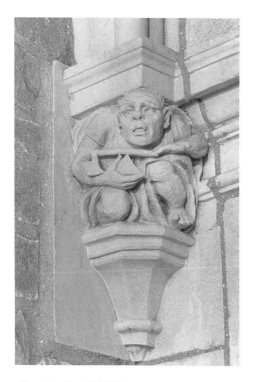

Fig. 63. *Corbel (W 3) representing commerce or economics ("Archimedes"), west passage*

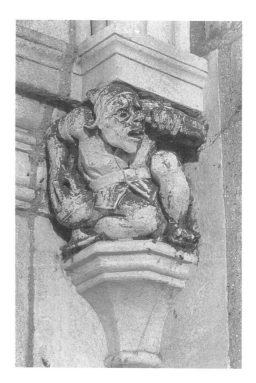

Fig. 64. *Corbel (W 1) representing an explorer or astronomy, west passage*

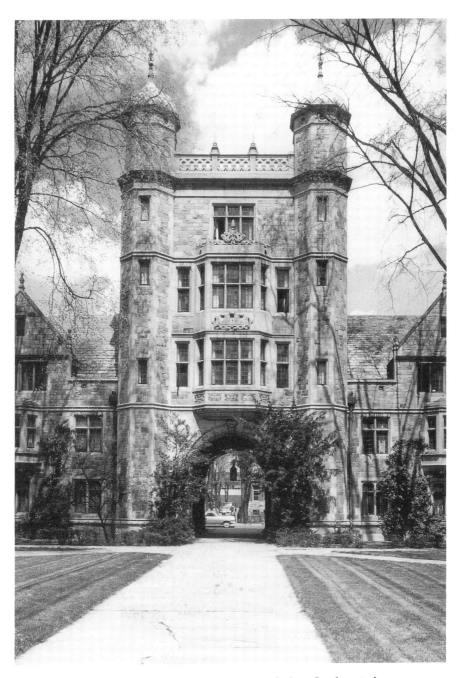

Fig. 65. *Towered gateway, main entrance to the Law Quad, central passage*

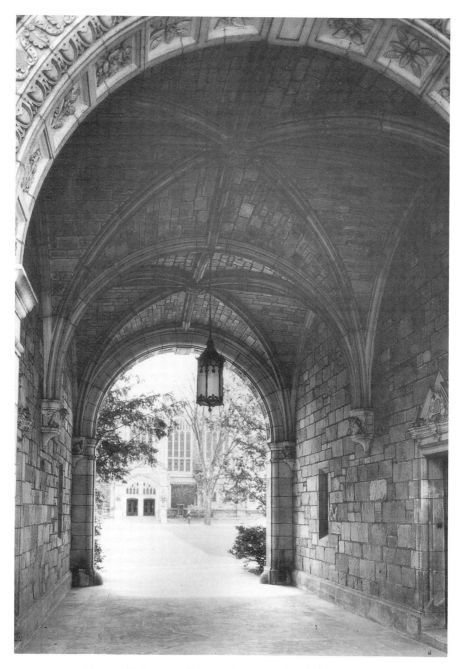

Fig. 66. *Entrance to the central passage with the large corbels*

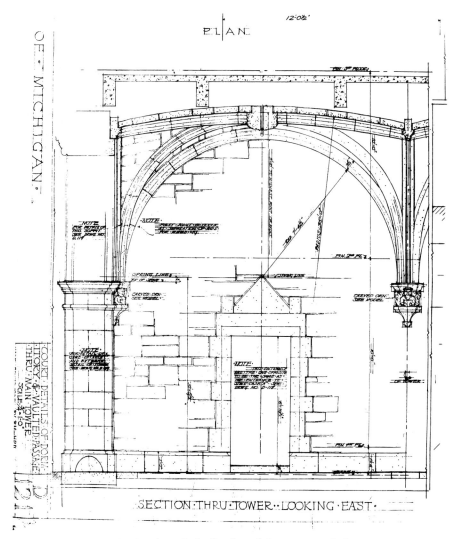

Fig. 67. *Section through the first bay of the tower, central passage,*
York and Sawyer drawing

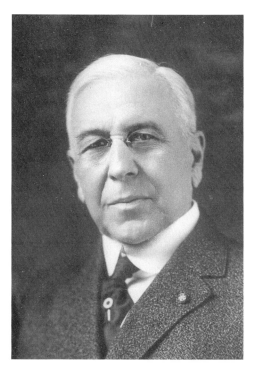

Fig. 68. *Carved corbel (C 2) representing*
President Harry Burns Hutchins,
central passage

Fig. 69. *Photo portrait of President Hutchins*

Fig. 70. *Sculptor's model for the*
Hutchins corbel

Fig. 71. *Carved corbel (C 4) representing President James Burrill Angell, central passage*

Fig. 72. *Photo portrait of President Angell*

Fig. 73. *Carved corbel (C 6) representing President Marion Leroy Burton, central passage*

Fig. 74. *Photo portrait of President Burton*

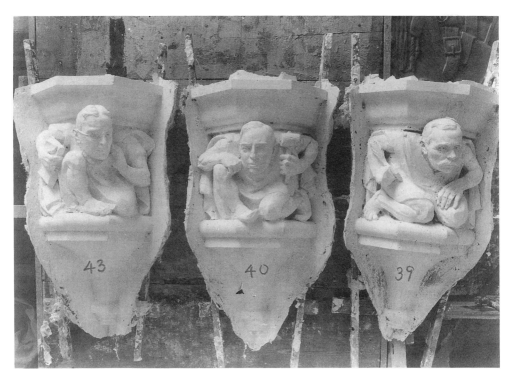

Fig. 75. *Sculptors' models for three corbels (C 1, C 6, and C 5), representing Secretary Shirley Smith (43), President Burton (40), and Professor Jerome Knowlton (39)*

Fig. 76. *Photo portrait of Secretary Smith*

Fig. 77. *Photo portrait of Professor Knowlton*

Fig. 78. *Sculptor's model for corbel (C 3) of Dean Henry Moore Bates*

Fig. 79. *Photo portrait of Dean Bates*

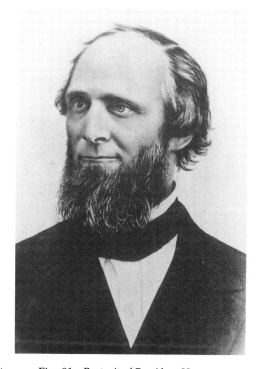

Fig. 80. *Carved corbel (C 5) representing President Erastus O. Haven, central passage*

Fig. 81. *Portrait of President Haven*

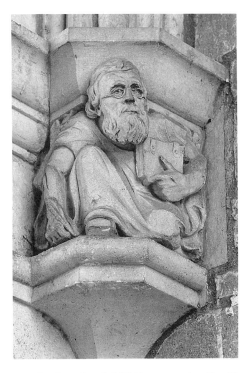

Fig. 82. *Carved corbel (C 1) representing President Henry Simmons Frieze, central passage*

Fig. 83. *Portrait of President Frieze*

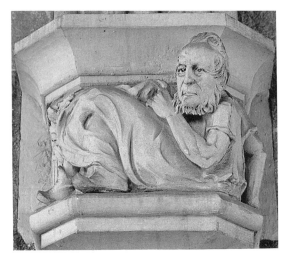

Fig. 84. *Carved corbel (C 3) representing President Henry Philip Tappan, central passage*

Fig. 85. *Portrait of President Tappan*

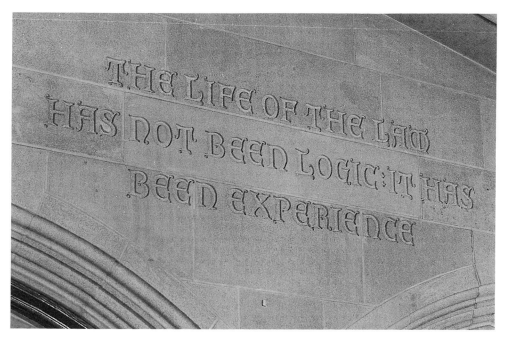

Fig. 86. *Hutchins Hall, inscription over north entrance to the glazed cloister gallery*

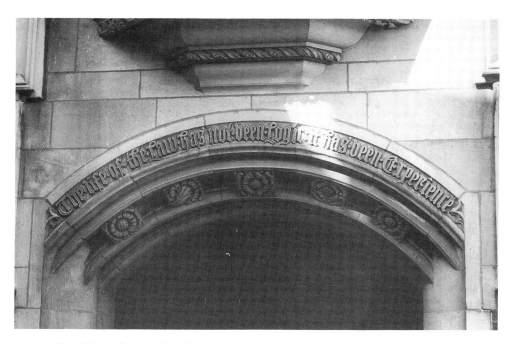

Fig. 87. *Sterling Law Building, Yale University, inscription over the entrance to the building, from the courtyard*

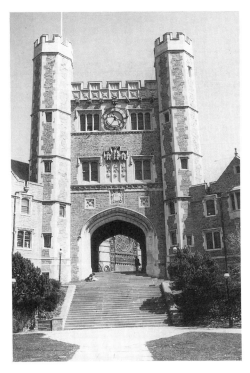

Fig. 88. *Blair Arch, Princeton University*

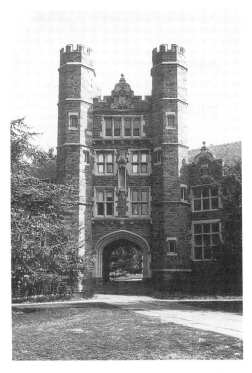

Fig. 89. *Rockefeller Hall, Bryn Mawr College*

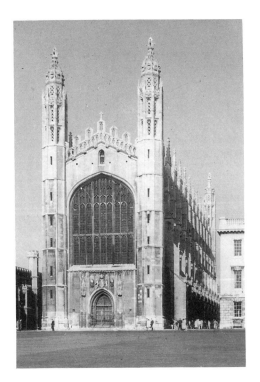

Fig. 90. *Cambridge, King's College Chapel*

Fig. 91. *Dining Hall, University of Michigan Law Quad, turret*

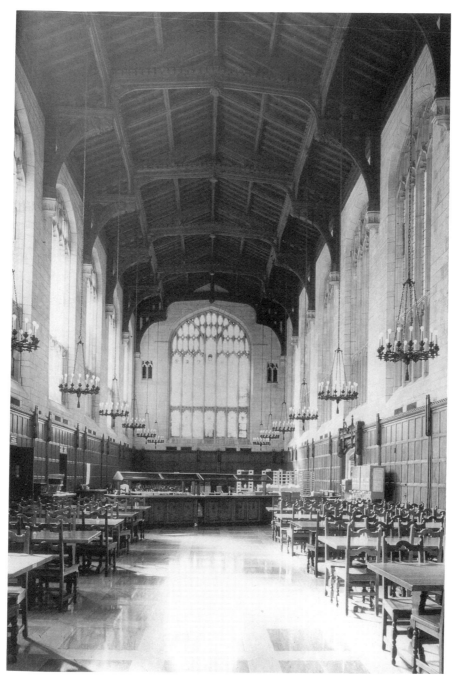

Fig. 92. *Dining Hall, University of Michigan Law Quad, interior*

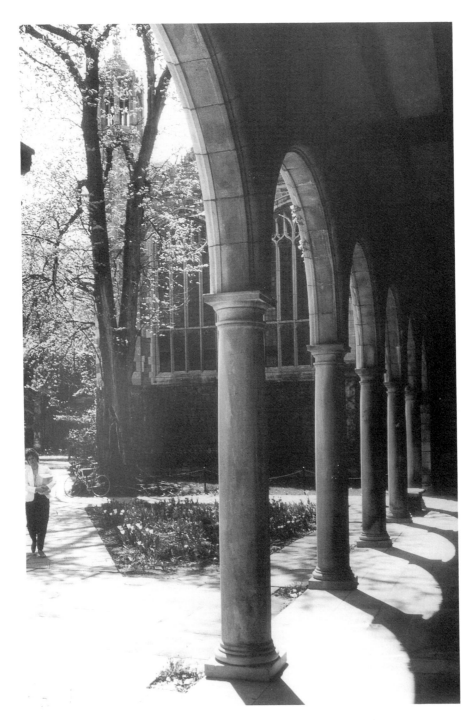

Fig. 93. *Dining Hall, University of Michigan Law Quad,*
from the arcade of the courtyard